GROSSMONT HOSPITAL

GROSSMONT HOSPITAL

A Legacy of Community Service

James D. Newland

THE
History
PRESS

Published by The History Press
Charleston, SC
www.historypress.net

First published 2018

Manufactured in the United States

ISBN 9781625859341

Library of Congress Control Number: 2017955128

This book is dedicated to all those Grossmont Hospital physicians, nurses, hospital staff, administrators, board directors, auxiliary members, volunteers, donors, civic leaders and community visionaries whose efforts have helped create this most indispensable public healthcare institution. This brief history is but a minor ode to all your hard work bringing comfort, care and compassion to those patients, family and community members who have been the beneficiaries of this institution's legacy of service.

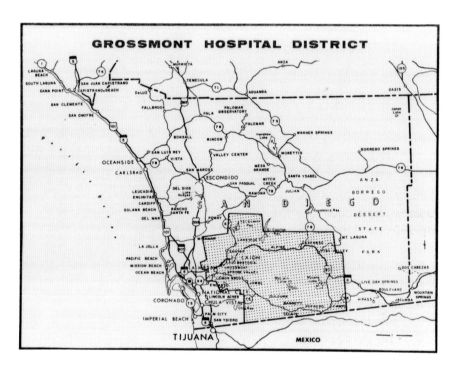

Grossmont Hospital District Map, circa 1970s. *Grossmont Hospital (GH) Collection.*

CONTENTS

PREFACE

When I first took on this project, I thought I had a fairly informed understanding of the history of this prominent local institution—Grossmont Hospital. As a professional historian and author of several local history books and a local history newspaper column, its basic story of community leaders gathering forces to create a most revered local, long-standing and public-owned healthcare facility for the rapidly growing post–World War II East County was considered the accepted narrative.

I also had some knowledge and understanding of the contextual history of American medicine and hospitals, having taken coursework focused on the social history of American medicine in graduate school. Although over twenty-five years ago, this academic background had provided a scholarly foundation for attempting to understand the continuing national saga of the peculiar evolution and controversial and complicated story of American healthcare that continues to be a confounding national malady in need of an equally complicated remedy.

Whether you consider access to healthcare a right for all or a market-driven commodity or you understand all the complex and idiosyncratic elements of the American healthcare system that is the crux of this divisive national policy impasse, the story of Grossmont Hospital will not likely provide a revelatory solution for such fundamental societal ills. Yet it is hoped that by following along with the story of our local hospital and healthcare district you may have a better understanding of that unique and challenging dilemma that American healthcare providers face.

PREFACE

For the vast majority of Americans, and especially those working within the constantly expanding and evolving science-based modern healthcare industry of the twentieth and twenty-first centuries, the dilemma was not in the altruistic goals of providing healthcare to all those who require it but how to organize, efficiently acquire, deliver and pay for the best care possible for all those in need.

Thus if we were to reconvene those locally notable civic leaders, physicians and citizens who gathered on July 24, 1955, to dedicate the brand-new and cutting-edge Grossmont Hospital, they might be amazed at the multilayered governance structure that has evolved to manage their beloved institutional creation. Their initial motivations were in providing a locally controlled public hospital as both a necessary healthcare provider and physical manifestation of their region's legitimacy and pride in becoming a modern community. They could not have foreseen, however, its evolution in response to American healthcare's unprecedented and unpredictable development over these sixty-odd years.

Yet Grossmont Hospital provides a great example for following the evolution of the American general hospital. It is a product of the great postwar expansion of community-based general hospitals. Unprecedented federal and state legislation and funding fueled the creation and development of such public hospitals as well as the large number of nonprofit and for-profit hospitals during the same period.

These public hospitals represented the promise to deliver all that was possible in modern medicine for their communities. American medicine's full-scale integration of science and technology led to the belief that these institutions reflected the superiority of our modern American society in addressing such fundamental communal needs.

It also represented the American hospital's transformation from the eighteenth- and nineteenth-century almshouse and indigent care facility to twentieth-century bastion of science-based treatment from the most educated, highly trained and professional physicians with the latest in equipment and technique.

The transformation of American healthcare was quickly adopted not only into the medical profession and administration of hospitals and healthcare but also reflected in the representation of doctors and hospitals in American popular culture. During this postwar period, some of the most popular television shows reveled in the life-and-death dramas that the American hospital signified. The long-lasting popularity of such television shows as the 1960s *Dr. Kildare and Ben Casey*, the 1970s hits *Medical Center and Emergency*,

10

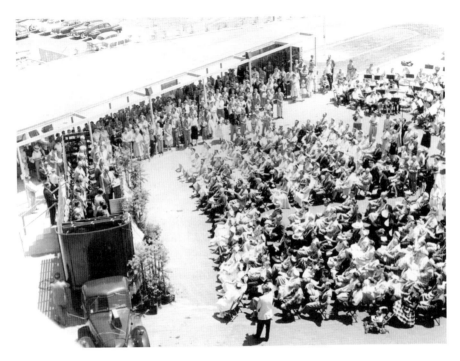

Grossmont Hospital dedication ceremony, July 24, 1955. *GH Collection.*

1980s *St. Elsewhere*, the 1990s–2000s *ER* and *Grey's Anatomy* and the fifty-plus-year run of daytime drama *General Hospital* attest to this fascination with the iconic American hospital and talented—and always handsome and attractive—healthcare providers.

As is generally the case, the reality of the American hospital and healthcare industry and its real-life cast of physicians, nurses, administrators and staff is often just as compelling a story than that of its popular culture surrogates. That is definitely the case for Grossmont Hospital. The hospital has had its own share of success and struggles; charismatic and talented physicians, nurses and administrators and board members; constant implementation of cutting-edge technology and technique; and award-winning and inventive architectural and engineering design, along with a headline-grabbing high-profile partnership/lease agreement, resultant legal challenges and—as any high-profile governmental entity—a bit of politics.

All the while, as noted earlier, Grossmont Hospital has continued to survive and thrive within the constantly evolving and peculiar advancement of the American healthcare system. From Grossmont's early efforts to

establish itself as a cutting-edge modern public hospital, including such an institution's inherent challenge for keeping up with the costly advances in technology and medical science, attracting and providing for the best physicians and staff while implementing an altruistic mission of a charitable service organization, the hospital and its varied partners and affiliates continue to hold that mission in earnest.

So as you read through the Grossmont Hospital story of constant growth, heroic and inventive treatments, continual striving for improvement and expansion all within the institutions' response to the ever-changing and complex bureaucratic and regulatory landscape, escalating costs of research, technological advancement and the healthcare system's reliance on both governmental and private health insurance and health maintenance organizations (HMOs) that dominate today's industry, hopefully you will find what has become ever more clear to me: that the "accepted narrative" of Grossmont Hospital is even more impressive than at first glance.

In order to properly contextualize this reflective but unique history, I have organized the book with an introductory chapter to explain the rise of the American general hospital from place of dread to essential community asset. In the first chapter I provide a brief history of the hospitals and healthcare pioneers of San Diego County, including the efforts of the small rural communities of East County on their unfulfilled attempts to provide hospital and health services prior to World War II. The second chapter illuminates the community leaders and physicians who took advantage of new state and federal legislation after World War II to develop a public hospital district from an idea to a reality within five short years. The following chapter will show how in just three more years the fledgling district designed, funded and built an award-winning modern hospital. Chapter 4 illustrates how the newly delivered Grossmont Hospital quickly captured the admiration of the exponentially growing region and expanded its facilities to match its constituents' needs. Chapter 5 continues the story through the 1960s, a decade in which the need to keep up with the growing population and its healthcare requirements placed space and staff at a premium for the young hospital. The next chapter reflects on not only the need to meet their patients' demands but also the rapid rise in costs, reliance of government reimbursement programs such as Medicare and the resulting regulatory oversight that put a new series of challenges to the legitimacy of the American hospital in the 1970s and 1980s. The final chapter traces the forward-thinking but at times controversial lease agreement with nonprofit Sharp HealthCare of San Diego in order to find a sustainable operating

model for the hospital. It relates the legal and political challenges leading to a new governance system and a joint strategic plan that look to prolong the district hospital and its healthcare services for the foreseeable future.

As with all my books, the breadth of the subject story outreaches the format of this volume. With only so many words and images as can be accommodated, there will no doubt be many significant and deserving contributors to this story (physicians, nurses, staff, administrators, volunteers, donors, board members and so on) who will not get mentioned. Any specific omissions are my responsibility and should not imply any slight of their significant contributions from their absence within this limited narrative.

ACKNOWLEDGEMENTS

This book is the result of the vision and dedication of the current Grossmont Healthcare District Board of Directors: Michael Emerson, Gloria Chadwick, Virginia Hall, Robert Ayres and Randy Lenac, along with CEO Barry Jantz and public relations consultant Rick Griffin. Rick was the dogged force who pursued and convinced me that this story of community service was worthy of a more thorough historical treatment. Sandy Pugliese of Sharp Grossmont Hospital was an indispensable asset for her locating and loaning of the hospital's historical archives for use in this project. Other district and hospital staff and consultants, including Vickie Bradeen, Lora Brown, Erica Calcuni, Andrea Holmberg, Kathy Quinn, Susan Stewart, Ann Tarvin and Joanne Watson, were also supportive by passing on input, images and contacts for interviews. Bruce Hartman, director of marketing and communications at Sharp Grossmont Hospital, and Grossmont Hospital Foundation Executive Director and CDO Beth Morgante were also key project supporters. Other contributors of memories and materials include Marcia Bair, Jean Chadwick, Daphne Galang, Patty Hardebeck, Michael Murphy, Danielle Ruiz, Jeffrey Scott, Bill Woolman and former board members Robert Yarris and James Stieringer. Another essential contributor is Dr. Ralph Ocampo, retiree and oral historian of the San Diego County Medical Society, who along with former Grossmont Hospital radiologist Dr. William Pogue and the many dedicated former hospital physicians of the RODEO (Retired Old Doctors Eating Out) Group collected a series of interviews with many of the pioneering and long-serving Grossmont

physicians. The La Mesa Historical Society also deserves credit for support, as does SDSU intern Rolando Arreola for his processing and cataloguing the GHD Collection. Finally but most importantly, I must acknowledge my wife, Jennifer, and daughter, Lindsay, for their patience, support and love during this latest project.

THE AMERICAN GENERAL HOSPITAL

A Truly Modern American Institution

American hospitals represent the promise to deliver all that is possible in modern medicine. Today most Americans have at least one experience with a hospital, and in fact, the vast majority of native-born citizens are delivered in a hospital, a practice that only became commonplace after World War II. Still, Americans' interaction with hospitals is not only common but also represents a great trust in the promise of American medicine.

This trust and belief in the efficacy of the hospital as a revered institution is also a relatively recent phenomenon. In the eighteenth and nineteenth centuries, American hospitals were generally a patient's last resort. Whether a physician or family member offered treatment, most people received their healthcare at home. Hospitals were generally for the poor and indigent—and often held the reputation as a place that people were admitted with little hope of recovery and/or leaving alive. Rarely would anyone of social or economic status ever be found in these pioneering and, compared to today's modern institutions, primitive facilities.

The earliest American hospitals were usually established to address particular diseases, chronic care or specific populations such as slave hospitals or asylums for the mentally ill. After the Civil War, the concept of the general hospital—one in which patients with many different ailments are given care, often within large and properly equipped wards with facilities and staff able to provide intensive care and emergency services, surgery and long-term treatments—grew in popularity. The newest of these Gilded Age general

hospitals were often government sponsored through the military or newly established Freedmen's Bureau and state veterans' homes.

The American general hospital also grew as a result of the modernization of American medicine with its newfound reliance on scientific research, technological advancement and professional expertise and licensing. Scientific advancements in bacteriology, surgery and other discoveries, such as X-rays and pharmaceuticals in the late 1800s and early 1900s, improved treatment effectiveness, legitimized the medical profession and justified sanitary facilities for enacting modern treatments. Thus the American hospital was reconstituted and legitimized in both professional and societal aspects. Historian Charles Rosenberg documents that by the early 1900s, the American hospital had grown into a more formal, bureaucratic and standardized institution than its almshouse predecessors. The American hospital had evolved, as Rosenberg notes, without formal planning, into a recognizable and consistent form and structure that met the modernizing society's medical needs, perceptions and expectations.

This led to a proliferation of American hospitals. From 1873 to 1920, the number of recognized medical (not including mental health–focused institutions) hospitals rose from 178 to nearly 6,000. These hospitals were generally divided into those publicly owned, proprietary (for-profit operations) and/or voluntary or nonprofit—the latter by far the largest group.

Therefore, by the 1920s the American general hospital had evolved into a modern institution that was technically open to all classes and strove to meet the latest in medical treatment and techniques. These goals and purposes of the modern American general hospital were ones that the majority of Americans considered to be appropriate for these now legitimate and trusted healthcare institutions. In combination with the unique sovereign rise of the self-regulated American medical profession, as sociologist historian Paul Starr so aptly documented in his landmark book, *The Social Transformation of American Medicine*, it is not surprising that by this time most communities saw a modern hospital full of scientifically informed, educated and licensed physicians with the latest in technological advances, equipment and facilities as a necessary community asset of benefit to all.

Early American Hospitals

The American hospital's rise to legitimacy is one that starts from humble beginnings. Spanish and French colonial hospitals, often associated with

Catholic charity efforts, are considered the earliest such institutions in the Americas. New Orleans' Charity Hospital, which dates to 1736, is considered the first charity hospital established in the current United States.

In British colonial America, the almshouse was the common institution that often delivered medical care. Almshouses were generally used to house poor, elderly or disabled people without family or those unable to support themselves. These charitable, often Christian institutions (alms being Christian charitable donations to aid the poor) date back to medieval England. The New York almshouse, later Bellevue Hospital, traces its origins to the 1730s.

Benjamin Franklin and Dr. Thomas Bond established Philadelphia's Pennsylvania Hospital in 1751. This American public hospital was instrumental in the University of Pennsylvania establishing its pioneering medical school in 1765.

In the early republic and antebellum United States, the hospital was not a major factor in healthcare delivery. Family members provided most medical treatment and nursing care in the decades prior to the Civil War. Trained physicians were rare in many communities, especially in the mostly rural states in the expanding frontier of the Midwest and South. However, as American society and civilization industrialized and moved west and was supplemented with new immigrant groups, those traditional methods of caretaking were challenged.

One of the major social effects of the antebellum period's popular religious revival and reform movements (known historically as the Second Great Awakening) was a more charitable view of institutional care. With the reform goals of remedying the great evils of society, the concept of care for strangers resulted in a greater acceptance of charitable institutions such as general hospitals. It was in this period that two of the first such institutions—Philadelphia General Hospital (1825) and New York's former almshouse, Bellevue Hospital (1824)—were developed as general charity hospitals in the modern definition.

Many of these early healthcare institutions were the result of reform-minded women, lay Protestant and Roman Catholic women being the most recognized for addressing social issues and concerns such as the treatment and care of pregnant women and foundling children. The aptly named Catholic Sisters of Charity was one of the church-affiliated women's organizations to establish and operate charitable hospitals in this period.

EMERGENCE OF THE GENERAL HOSPITAL

The American Civil War was an important catalyst for promoting the modern general hospital. Based on the model of military field hospitals that British social reformer and nurse Florence Nightingale helped establish during the Crimean War (1853–56), both the Union and Confederate armies spread the general hospital's organizational structure, providing broad-ranging medical treatments.

After the war, the rapid rise of industrialization and urbanization reinforced the need for such public and private general hospitals to meet the needs of the diverse and modernizing American society. The American general hospital evolved in response to growing scientific knowledge, technological advancement and professionalization. New understandings of contagious diseases such as tuberculosis led to the establishment of new treatment institutions, including sanitariums, asylums and so on. Yet as those specialized institutions addressed specific illnesses, the need for providing medical institutions that could not only treat disease but also provide a venue for critical care, surgery and modern, science-influenced medical treatment became essential.

The societal need for general hospitals was reflected in the fact that over 65 percent of American hospitals in the 1920s would be classified as general. Whether those hospitals were publicly operated, proprietary for-profit (usually operated by physicians) or voluntary nonprofit institutions, the old stereotypes of the hospital as a place of dread and death had been replaced with a place of science, professionalism and hope.

The modern societal elements that had fueled this evolution were many. One of the first was the professionalization of nursing. After the Civil War, reform-minded women advocated for the training of nurses for hospital work. The first professional nursing training programs were established in Boston, New Haven and New York in the 1870s. By the early 1900s, many hospitals had opened nurse training schools to provide this necessary and growing and accepted profession—especially accepted for career-minded American women. It also codified the character-driven standards for the modest, deferential and above all obedient to the physician American nurse. This professional hierarchical order would be considered the standard for many decades to come in American hospitals.

Another reflection of the times found in the new American general hospital was the role of science and technology. The ability to take advantage of new techniques in surgery along with knowledge of sanitary procedures

supported both the expansion and success rates of new medical techniques and treatments. These medical advancements reinforced the value and role of highly trained physicians and expanded the patient populations eligible for treatment. All this increased the public's acceptance and faith in modern medicine and physicians who had access to the latest in facilities and equipment with which to practice their science-based profession.

Hospitals' need for such highly trained and skilled physicians also led to the expansion of medical education and the hospital's role in providing the necessary venue for practical applied experience (internships). Hospitals were rewarded for affiliation with only professionally credentialed medical schools.

For the new modern hospitals, unlike in the era when matrons and trustees of sanitariums provided care for those suffering from chronic diseases, the general hospital required a highly trained and informed staff of physicians. The power of the self-regulated medical profession and its insistence on certified medical training and licensing made physicians the driving force in the modern hospital. It also established the institutional competition between hospital administrators and doctors. The legitimacy of both professions was codified in the incorporation of the American Medical Association in 1897 and the administrators' own American Hospital Association in 1899.

Peculiar to most professions in this time, the American medical profession was able to develop, as historian Paul Starr chronicled, as a self-regulating sovereign profession that would dominate the healthcare industry in the early twentieth century. This hierarchical status for physicians would allow them to establish the accepted standards for medical care and its delivery. After World War I, American physicians formalized the standards for delivery of treatment at hospitals: diagnosis, assessment and treatment for illness, emergency acute care and recovery for critical injuries and life-threatening conditions. Doctors were able to direct hospitals toward development as acute care facilities in lieu of preventive care. Their lobbying efforts restricted the growing public health dispensaries and community clinics to social work status.

With this healthcare delivery delineation, the cost of hospital care became a central concern of hospital administrators in the 1920s, especially with the necessary expenses in employing the best-trained and skilled physicians along with requirements and expectations of technologically advanced equipment and sterile facilities.

Although lobbied against as socialist or communist at worst, the issue of third-party medical insurance would soon arise to address the question of costs and coverage of the poor and disenfranchised. Yet by the 1930s, most

Americans could choose a hospital because of its location and affiliation with their personal doctors instead of a religious, cultural or economic association. Although the Great Depression would see rise of the Blue Cross system as a potential group insurance model, compulsory health insurance could not be passed, even within the Roosevelt Administration's similar New Deal successes, such as social security.

Therefore, by the eve of World War II, American general hospitals had become an accepted institution that was considered a necessity for all civic-minded communities. As more and more Americans engaged with these institutions, it was soon recognized that many regions needed modern hospital facilities.

The federal government's support efforts for World War II would prove pivotal in establishing funding for new hospitals in booming postwar America. Defense funding such as the Lanham Act of 1941 committed federal funds for expansion of medical services and hospitals in regions supporting the war effort, whether rural or urban. This set precedent for government funding of both public and private hospitals after the war.

POSTWAR PROLIFERATION OF HOSPITALS

The federal government's funding of medical facilities and hospitals made a great imprint on American society. The Allied victory emboldened the United States into the belief that solutions to any problem, social or otherwise, could be accomplished. Lobbying from the American Hospital Association led to both the wartime Lanham Act and the Emergency Maternity and Infant Care Act of 1943, which helped fund new hospitals and make them the preferred facility for child delivery. By 1955, well over 90 percent of American babies would be born in hospitals. With the country in the throes of the famed postwar baby boom, this evolution was timely.

With the massive postwar need to address the expectations of healthcare for all Americans, the hospital lobby helped establish a national standard of providing four and a half hospital beds per thousand residents nationwide. This goal required expanding hospital services to all regions and communities, resulting in new and fundamental legislation in support of hospitals. The Hill-Burton Act (also known as the Hospital Survey and Construction Act of 1946), named for Senators Harold Burton of Ohio and Lister Hill of Alabama, was foundational for those efforts. The act provided

funding to states to identify and analyze their hospital needs and construct new institutions to address those needs.

Hill-Burton expanded hospital services to many rural and rapidly growing suburban areas. It cemented the role of hospitals as the preferred healthcare institutions for delivering acute, short-term care with the latest and most advanced medical care available. It also required expansion of state and local infrastructure, bureaucratic support and regulation to help deliver funding to those communities deemed most needy—or to those best in organizing local and private initiative.

The postwar era confirmed the promise of the American hospital as the cutting-edge scientific healthcare institution reflective of all the positive attributes that modern American medicine could provide. It was during this time, as historian Rosemary Stevens notes, that American hospitals fully believed in their ability to balance the costs of constantly evolving technology with a community service ethic to reconcile the altruistic goals of medicine within a business model that would not leave anyone unserved.

During the 1960s, the constant challenge facing hospitals was funding and staffing high-need and high-cost emergency and intensive care units. Such growing services required newly trained specialists and nurses and coordinated public safety and emergency services systems.

As American hospitals struggled to keep pace with advancements in medicine and healthcare, the costs began to increase rapidly. Such costs were passed on to the patient, making the growing third-party insurance plans provided by many larger employers and unionized workers more and more important to hospital bottom lines.

In the 1960s, rising costs led the general population to concur that healthcare and hospitals needed cost control and reform. The question of national healthcare coverage rose up again. However, universal health insurance was not politically obtainable. Instead, Congress passed and President Lyndon Johnson approved the Medicare and Medicaid programs in 1965.

Medicare signaled a major watershed in hospital and healthcare finance. When increasing regulation of these programs in the 1970s and 1980s led to additional administrative costs, and reimbursements changed from incurred costs to those government regulators would approve, hospitals' reliance on such revenue sources proved counterproductive.

By the 1990s, American hospitals were facing a harsh reality, as reliance on insufficient government reimbursement required new revenue sources for financing required services. Hospitals have then subsequently turned

to agreements with large-scale insurance groups that can provide steady income with controlled costs. Known as Health Maintenance Organizations (HMOs) and often referred to as "managed care" programs, these agreements have become a necessary aspect of hospital business models. Consolidation and mergers among hospitals and healthcare systems, moves to reduce costs through less costly outpatient treatments, reduced hospital stays and preventive care and public health education have all become part of twenty-first-century hospital operations.

From its origins as a place of last resort and destitution to its rapid rise as the revered model institution reflecting the promises of modern American society, through its role within the complex and controversial question of how and to whom healthcare is to be provided, the American general hospital continues to play a significant and sometimes uncertain role in today's healthcare industry.

SAN DIEGO COUNTY HEALTHCARE PIONEERS

CULTURAL ORIGINS OF CARE

For those pioneers of San Diego County living one hundred years before the creation of Grossmont Hospital, it would have been unlikely to imagine a vast majority of the community's citizens taxing themselves to form a public hospital. Certainly San Diego County in the 1850s was a much smaller community. Its rise in population from a few thousand to over half a million residents a century later matches the exponential development of the region's healthcare.

The Kumeyaay and other Native American cultural groups practiced traditional care for centuries. Spanish colonial explorers and settlers of the eighteenth century provide the first documentation of medical treatment and care. These Spanish colonial pioneers established the earliest Euro American settlements in today's San Diego County, including the Catholic missions (San Diego de Alcala and San Luis Rey) and *presidio* (military community) that evolved into Old Town San Diego. These frontier settlements also included "hospital-like" facilities to address the medical and healthcare needs of the missionaries, soldiers and settlers. Unfortunately, the majority of those requiring care were the large number of Native American neophytes who had been incorporated into the mission system. Social disruption and introduced diseases caused widespread devastation to the native population.

Interestingly, one of the earliest and most legendary colonial era healthcare pioneers associated with Mission San Diego was Doña

Apolonaria Lorenzana. Lorenzana, a pious unmarried woman who had dedicated her life to serving the mission, was renowned as a *curandera* (folk healer). For her services to the mission, she was awarded the Rancho Jamacha, the 8,881-acre grant that surrounded the Sweetwater River in the area of today's Spring Valley and Rancho San Diego areas—all now part of the Grossmont Hospital District service area.

PIONEERING SAN DIEGO HEALTHCARE

Once the United States occupied and acquired Alta California in 1848 after the war with Mexico, a steady stream of Euro Americans came to the region. Some of these early soldiers-settlers who came to San Diego were physicians who started practices and took on roles in enhancing healthcare and medical treatment for the arid American frontier community. As Michael Kelly documented in his articles on the origins of nineteenth-century healthcare in San Diego, the community's recognition of the need for healthcare and hospital facilities dates back to the origins of the city and county governments.

In 1850, the newly formed City of San Diego's Common Council established a board of health specifically to address the needs of the indigent. County records identified the first public hospital in the now legendary cobblestone jail in Old Town the following year. During the ensuing two decades, the county would move the hospital around to various buildings in Old Town San Diego. These initial government-based healthcare efforts reflected the almshouse traditions of most early American hospitals. City and county records from the 1850s documented the county's hospital accounts and the city's simple service contract with Dr. David Hoffman. These efforts served the county's indigent sick, including treatment of the city's poor and destitute.

Dr. David Hoffman was typical of the pioneering physicians of the early American period. Born in New York, he traveled overland as a young man to San Francisco during the gold rush. Hoffman graduated from Toland Medical College in San Francisco prior to taking a position as ship's surgeon for the Pacific Steamship Company. In 1853, he came to San Diego where he set up a practice advertised in the local *San Diego Herald* newspaper as "Dr. D.B. Hoffman, Physician, Surgeon, Accoucheur [male midwife]."

As one of a few trained physicians in the city, and a man of letters who also had obtained a law degree, Hoffman soon found positions as

county coroner (1855), city trustee (1857), district attorney (1859), state assemblyman (1862), school trustee (1865), presidential elector (1868) and collector of the port (1869) from his offices in Old Town. In 1870, he organized the ten doctors in the now booming city of 2,300 to form the San Diego County Medical Society, which he served as first president.

FIRST SAN DIEGO HOSPITALS

Hoffman moved to New Town (today's downtown) in 1869. After diagnosing an outbreak of typhoid fever in the growing port city, he wrote a letter to the City Board of Trustees identifying the need for permanent facilities to treat the indigent sick. Hoffman's efforts resulted in the Board of Supervisors contracting with individuals or groups willing to provide treatment for the indigent and disabled on their own properties. Shortly thereafter, the city would establish its "Pest House" in the undeveloped City Park (now Balboa Park). It would not be until 1878 that the county requested proposals for the purchase of land for its own hospital purposes.

In 1880, the County Board of Supervisors purchased acreage in Mission Valley below today's Sixth Street/State Route 163 grade for a hospital. The supervisors chose this property from eight proposed sites around San Diego for the newly established County Hospital and Poor Farm. By the late 1880s, the property included two ward buildings, a dining room, the superintendent's quarters, a laundry, a storeroom and a carpenter's shop/ old men's quarters. Those patients able to work helped with tilling the four acres of gardens and four acres of orchards. The sixty-bed facility averaged around thirty patients during the 1880s, the vast majority indigent men. The county physician was in charge not only of treating those at the hospital but also indigent patients as well as any inmates of the downtown county jail.

When the railroad permanently connected San Diego to Los Angeles and the rest of the country in 1885, the resulting real estate boom saw San Diego's population rise from an estimated five thousand in 1885 to a reported forty thousand by 1888. Although San Diego City's population would drop back to sixteen thousand by 1890—after the speculative boom busted—much new infrastructure was established.

It was in this period that much data about this early public hospital operation was reported in the 1889 *First Annual County Hospital Report*. County physician Dr. Joseph LeFevre, an Indiana native who attended college in

Iowa and Missouri before receiving his medical degree in California in 1881, authored the report. LeFevre's report noted the ailments, surgeries and twenty-one deaths that had occurred at the County Hospital, the most common cause of death being from tuberculosis.

Southern California, a remote, arid part of the United States, had been seriously promoted in the late nineteenth century as a perfect place for curing lung and respiratory diseases such as tuberculosis. Many physicians in the Midwest and eastern United States would prescribe moving to Southern California as a treatment. A local, Dr. Peter Remondino, who came to San Diego in 1872, authored several books, including *Longevity and Climate* (1890) and *The Mediterranean Shores of America* (1892), promoting both the region and its health-boosting climate.

As such, many of the early hospital facilities were sanitariums, both proprietary (for profit) and nonprofit. Especially after the transcontinental railroads opened up relatively easy access in the 1880s, the promise of a healthy life in a land with "no weather" that had a special curative climate was sold to promote the region. Not surprisingly, Drs. Remondino and Thomas Stockton opened the first private hospital/sanitarium in San Diego in 1879. Two years later, female Australian Dr. A.M.L. Potts began the Paradise Valley Sanitarium in National City (precursor to today's hospital of the same name).

As the population grew exponentially during the boom years, other county physicians recognized the need to provide more hospital facilities for the growing region. In 1887, Dr. H.W. Yemens, a former head of the U.S. Marine Hospital Service, was hired to observe and identify the region's hospital needs. During this period, both the Catholic Sisters of Charity's hospital facility in Ocean Beach and the Good Samaritan Hospital downtown were established, in addition to a few small, private institutions to help address the region's growing healthcare needs.

The most promising of these private nonprofit hospitals was the Catholic Sisters of Mercy's St. Joseph's Hospital, Sanitarium and Home for the Aged, established in the soon-to-be-named Hillcrest area in 1893. The Sisters' facility became recognized as one of the most modern and well equipped in the county. In 1898, able administrator Mother Superior Michael led efforts for a new wing that would double the hospital's capacity. Two years later, a new convent was built next to the hospital for the Sisters, who served as the best-trained nursing force in the region. The Sisters also acquired a 1,039-acre ranch near Del Mar in 1899 that became a major producer of fresh produce and dairy products for the growing institution.

HOSPITALS FOR THE NEW CENTURY

St. Joseph's represented the first of the modern hospital organizations in San Diego County. Civic and community leaders partnered shortly after the turn of the century to undertake a major renovation for St. Joseph's. Improvements included a new fourth-floor addition and the first fluoroscope (a type of X-ray machine) in the county. In addition, St. Joseph's opened the first formal nurse training school in the region in October 1904.

Bishop Thomas James Conaty dedicated the "new" St. Joseph's Hospital on June 28, 1904. San Diego mayor Frank Frary and many local community leaders attended the ceremony. Leaders noted that with its 220 rooms, affiliated physicians, latest in equipment and modern facilities, nursing school and elderly care services, the hospital represented an essential community asset. The Sisters held an open house in August and led visitors through, as reported in the *San Diego Union*, "sixty-four large, well lighted rooms, provided with all the modern conveniences…making 126 guest rooms in the

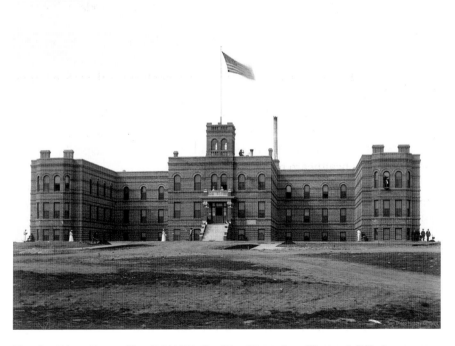

New San Diego County Hospital, 1904. *San Diego History Center Photograph Collection.*

main building alone." As hospital historian Bill Finley noted, this made St. Joseph's one of the largest and most comprehensive healthcare facilities in the region at the time.

One of the most important aspects of St. Joseph's Hospital and Nursing College's success was its relationship with local physicians. In October 1904, the *San Diego Union* listed the well-trained and well-rounded staff and faculty consisting of Dr. F.R. Burnham, obstetrics; Dr. R.G. Hulbert, surgery; Dr. M. Lamont, women and children's medicine; Dr. A.J. Elliott, bacteriology and pathology; Dr. C.C. Valle, anatomy and physiology; and Dr. Peter Remondino, practical (general) medicine.

The desire for modern hospital facilities had led the county to expand its hospital and poor farm operation. In 1903, the county funded and constructed a new, modern three-story building in the same Hillcrest neighborhood as St. Joseph's. Newspapers reported on the train of horse-drawn wagons and ambulances that transported the ninety resident county patients to the new "E-shaped" building on the rim of Mission Valley just west of First Street.

Additional private institutions from this period include the Agnew Sanitarium and Hospital at Fifth and Beech Streets, Dr. Edward's Sanitarium at Fourth and First and the Kneipp "Bavarian" Sanitarium on First Street.

MODERNIZING SAN DIEGO'S HOSPITALS

The 1910s were an era of progressive politics and social movements bent on improving society, including the rapidly urbanizing and industrial American society's public health. As San Diego's population continued to double each decade in the early twentieth century, civic and community leaders as well as physicians and healthcare providers moved to expand and improve hospital facilities. The San Diego City Department of Health reported in its *Annual Report of 1916* on the great need for modern hospital facilities. It called for healthcare facilities with professional staff to augment volunteers and social workers to address the challenges of treating the poor and indigent along with educating those ignorant of healthcare and the values of sanitary living.

In 1912, the Talent Workers, a local social work organization with a free clinic in downtown San Diego, called for a $50,000 campaign to build a modern hospital, drawing press attention and community interest. Mother Michael of St. Joseph's also recognized the need for a new, state-of-the-

art facility for St. Joseph's as early as 1915. She once again helped rally the community to the cause. Things progressed rapidly after San Diego businessman Anson Stephens willed the Sisters of Mercy a six-acre plot just half a mile from their St. Joseph's facility, at Fifth and Washington Streets. Soon after, a formal fundraising campaign was conceived.

Starting in later 1916, as the Panama-California Exposition was nearing its conclusion, these civic and community leaders rallied a campaign for a new, modern and fireproof $220,000 hospital. The list of supporters included key businessmen, politicians, lawyers, bankers, physicians and developers with legendary San Diego family names such as Wegeforth, Wilde, Spreckels and Fletcher. The campaign seemed to be moving forward when the United States entered World War I in April 1917.

World War I cemented San Diego's relationship with the U.S. Navy as an essential homeport and training facility. But it did postpone the city's hospital campaign. However, it also brought about the establishment of the Naval Hospital in Balboa Park. In 1919, the city deeded seventeen acres that year to the navy to formally establish its own modern hospital facility from its original War Dispensary command. By 1922, the Naval Hospital had administrative, surgical and ward buildings to serve all active servicemen and veterans of the Great War. Additional acreage would be acquired in the late 1920s, creating a bed capacity of over one thousand. The Naval Hospital would also establish the historically significant pipeline for military-trained doctors into the San Diego region that continues through today.

In the meantime, St. Joseph's continued to grow and professionalize its operation. In 1921, it became the first hospital west of the Mississippi to gain accreditation from the American College of Surgeons. St. Joseph's accreditation solidified its professional standing, helping attract the best local physicians to its staff and subsequently influencing its role as the main regional physician training hospital. Although the expansion plans for the new St. Joseph's Hospital hit financial troubles in early 1923, the groundbreaking for the new six-story fireproof hospital at First Avenue and Washington Streets occurred later that year. A corporate restructuring under the name Mercy Hospital greeted the new hospital's opening in November 1924. Community support for the construction of two additional wings in the late 1920s made Mercy the leading modern hospital in the region.

MERCY HOSPITAL

FOUNDED IN 1890

Mercy Hospital advertisement, 1924. *La Mesa Historical Society Archives.*

DEPRESSION ERA TO WARTIME BOOM

By the time of the Great Depression's devastating economic effects, San Diego had developed five accredited modern hospitals: Mercy and San Diego County Hospitals in Hillcrest, La Jolla's Scripps Memorial, National City's Paradise Valley and the Naval Hospital. Although economic growth in the interwar years had slowed during the early 1930s, San Diego was primed for the exponential growth that World War II and the postwar period would bring.

With the doubling of the county's population during the "Boomerang Boom" from 1938 to 1945, both Mercy and Naval Hospitals grew rapidly. Mercy Hospital became one of the busiest civilian hospitals in the United States. By 1940, the hospital was delivering an average of 250 babies a month, with over 4,000 in 1943 alone. The navy acquired another fifty acres of Balboa Park land to aid in its growth from 1,424 beds before World War II to a height of 10,499 beds during the war.

In the immediate postwar years (1946 to 1950), Mercy would reflect both the county's population reaching half a million and the famed baby boom by delivering some 21,383 babies during those years. By 1949, it also had become recognized for its evolution into a modern medical institution with American Medical Association (AMA) accreditation as an internship hospital for specialties such as pathology, obstetrics, surgery, internal medicine, gynecology and anesthesiology.

Overall, by 1952, the hospital business in San Diego represented a $6 million industry with 1,889 beds—with expectations of another 245 beds to be added within the next two years—and over 2,436 employees. Local and state healthcare planners knew that with the region's connection to the metropolitan water system and growing aerospace and military industries, San Diego County's exponential growth was likely to continue—as would its resultant healthcare needs.

East County Healthcare Pioneers

In the early postwar period, San Diego's East County was still a rural, unincorporated area. To most San Diegans, the large, arid and remote area was the backcountry. Only La Mesa and El Cajon had been incorporated—both in 1912—and they barely held six thousand residents between them in 1940. But similar to its more urban neighbors to the west in San Diego, East County recognized the signs of impending large-scale suburban growth, and providing that population with expanded healthcare needs was essential—especially since the only semi-equipped hospital facility in the region at the end of World War II was the thirty-four-bed La Mesa Community Hospital.

East County's healthcare pioneers made up a small but dedicated group of physicians and community visionaries. One of the first resident doctors of note was the aforementioned Dr. David Hoffman. Hoffman moved to Spring Valley in the 1880s, and in the 1889 County Report, Hoffman provided the only physician's assessment from the area within today's Grossmont Hospital District boundaries. Hoffman wrote, "Spring Valley, with a population of over 300, has been during the past year a very healthy locality. There has not been a single death, and most common forms of disease are colds and mild fevers. There have only been four deaths from disease in three years."

Unfortunately for Hoffman, he would be the first Spring Valley resident to pass away, just a few months after publication of his proclamation of the healthy nature of East County.

With the city and county's population stabilizing in the 1890s, the number of physicians in the East County reflected the small, rural population. In 1900, San Diego City had approximately 80 physicians for its population of 17,700, half of the county's 35,070 residents. For the southeast quarter of San Diego County (now referred to as East County), the population was estimated at roughly 2,000. The 1899–1900 San Diego County Directory identified 9 physicians for this over 700,000-acre rural region.

HEALTHCARE IN A GROWING REGION

With the announcement of the scheduled opening of the Panama Canal and the plans for a direct railroad to connect San Diego to the east, San Diego County would begin each decade of the new century with exponential population growth. In addition, the development of the automobile and subsequent highway systems would trigger rural East County's first initial suburban development.

Situated along the San Diego and Cuyamaca Eastern Railroad, the small communities of La Mesa Springs and El Cajon were the first to incorporate, in 1912, each just meeting the minimum six hundred residents required. In the meantime, although the population in rural East County likely doubled in that first decade, the number of physicians listed in the 1910 County Directory had only grown to fifteen—six of whom lived in La Mesa Springs (today's downtown La Mesa). The other physicians were situated throughout the East County in Lemon Villa (today's El Cerrito/College Area), Campo, Dulzura, Jamul, Lakeside, Lemon Grove, Potrero, Santa Ysabel/Julian and Ramona.

It was in the La Mesa area that the first healthcare institutions were established. In 1906, Dr. Joseph A. Parks opened his Parks Sanatorium. Parks, a Tennessee native and Vanderbilt graduate who was an expert in respiratory diseases of the chest and throat, had come to California in 1902 to treat his own respiratory ailments. Established to take advantage of the "year round climate" to pursue the "open air treatment" becoming popular for lung and throat diseases, the facility featured well-ventilated buildings and tents. Parks would close the sanatorium in 1909, reportedly selling off

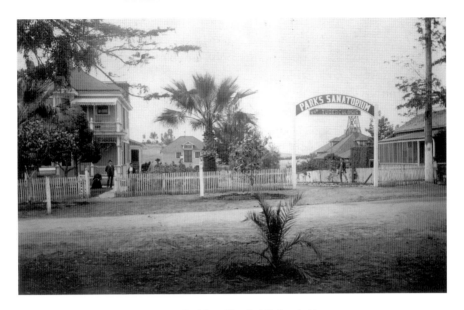

Park's Sanitorium, La Mesa, 1909. *La Mesa Historical Society Archives.*

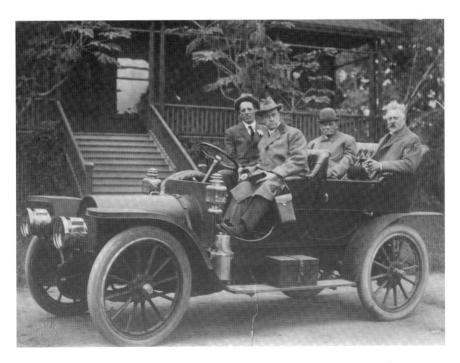

Ed Fletcher (*left*) and Grossmont namesake William Gross (*far right*), circa 1910. *Guy Collection, La Mesa Historical Society.*

his tent cabins to another group—the San Diego Tuberculosis Association. The association apparently used them for its Rest Haven camp in the Lemon Villa/El Cerrito area west of La Mesa.

Dr. Parks would continue to practice medicine and serve as a community leader in La Mesa. He was elected to the City Board of Trustees in 1912 along with fellow physician Dr. Charles Samson, who would be elected the first president of the board (de facto mayor). In 1918, Dr. John Mallory, another La Mesa resident, would serve as board president before both he and Parks resigned their positions to join the U.S. Army medical corps during World War I.

ENVISIONING AN EAST COUNTY HOSPITAL

World War I interrupted San Diego's dreams of becoming a major West Coast industrial port city to rival San Francisco. The opening of the Panama Canal led civic and business leaders to dreams of rapid growth similar to that which Los Angeles was experiencing one hundred miles away. Similarly, the war also delayed the development of San Diego's first fully equipped modern hospital until the mid-1920s.

Although a much smaller community in size, the residents, civic and community leaders of East County had similar aspirations catalyzed by Colonel Ed Fletcher. Fletcher came to San Diego in 1888 during the great boom. Traveling the backcountry as a produce salesman, he quickly recognized how important infrastructure such as roads and water would be in making these rural lands valuable and profitable. In examining his papers, held today at the UCSD Special Collections archives, one could initially conclude that Fletcher appears to have been involved in nearly every water, road and development project in the county.

Two of Fletcher's most beloved and lasting enterprises were East County projects. The first was the Grossmont Colony on the former lands of the Alta and Villa Caro Ranches located in the pass between La Mesa and El Cajon Valley. In partnership with entertainment agent William Gross, Fletcher planned the Grossmont community as a bohemian artist colony carved into the rocky hillsides. He also partnered with Montana capitalist James Murray to purchase the insolvent San Diego Flume Company, the main water supplier to the La Mesa, Spring Valley and El Cajon areas, and revitalize its operations and infrastructure as the Cuyamaca

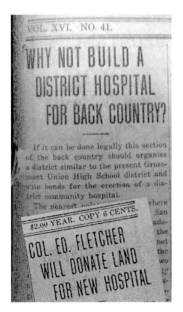

VOL. XVI. NO. 41.

WHY NOT BUILD A DISTRICT HOSPITAL FOR BACK COUNTRY?

If it can be done legally this section of the back country should organize a district similar to the present Grossmont Union High School district and vote bonds for the erection of a district community hospital.

The nearest ...

$2.00 YEAR. COPY 6 CENTS.

COL. ED. FLETCHER WILL DONATE LAND FOR NEW HOSPITAL

La Mesa Scout headlines calling for a local hospital, October 1921. *La Mesa Historical Society Archives.*

Water Company. In addition, Fletcher was an essential proponent in obtaining federal, state and private funding for the development of new auto highways for connecting San Diego to East County and through the desert and beyond. Locally, he also provided free land from his Grossmont holdings and stone from local quarries to help the new Grossmont Union High School District construct its campus at the top of renamed Grossmont Pass.

Thus, when *El Cajon Valley News* and *La Mesa Scout* editor C.S. Smith published an editorial in October 1921 calling for a district hospital for the backcountry, it would be Ed Fletcher who would become the idea's number one proponent. In the article, titled "Why Not Build a District Hospital for Back Country?," Smith wished to follow Fletcher's leadership to develop a public hospital district similar to that of the recently created high school district. He addressed an argument that still holds up as a healthcare concern today. He noted that St. Joseph's Hospital was "the best money could buy," but the next best, County Hospital, was aimed at covering the indigent. Therefore, East County's main population, the middle class, was left out of convenient, affordable healthcare and hospital facilities.

Smith noted that publicly held community hospitals had been established in other states, and public bonds would be the best way to capitalize the assumed $50,000 cost for a modern community hospital for East County. Smith asserted that "hardly a week goes by without numerous emergency cases handled by local doctors, often accidents along the highways to which patients are rushed to doctors in Bostonia, El Cajon or La Mesa for first aid. And while waiting hours for an ambulance to transport them to hospitals in San Diego that many lives are lost." He also noted that all the local physicians were in agreement on this need and believed that it could be a full service community asset—hosting classes on public health issues such as nursing, care of infants, first aid and other topics of which the average resident was woefully ignorant.

Two weeks later, Ed Fletcher's response was published. Fletcher's letter included his offer to provide land for the new hospital from his Grossmont holdings on the bluffs behind the new high school site. In an article including Fletcher's offer letter, Smith noted that El Cajon resident Dr. Charles Randall Knox, son of town founder Amaziah Knox, had already contacted attorney P.S. Thacher regarding the legality of forming such a state-authorized hospital district. Thacher responded that California did not have such a law, but that cities of the sixth class such as La Mesa and El Cajon could use their bond authority to finance such services. Smith ended with a fiery response that East County should "not remain laggard in supplying its own crying needs when those wants can without much difficulty be adequately stilled and fed."

Apparently, several issues distracted the community from moving forward on this issue in 1921, one being the greater need that C.S. Smith and the customers of the Cuyamaca Water Company faced. Fearing that Fletcher and Murray's Cuyamaca Company would be sold or usurped by the City of San Diego, Smith helped promote a $2.5 million bond act to purchase the water company and place it within the locally controlled La Mesa, Lemon Grove and Spring Valley Irrigation District (later Helix Water). The passage of that bond act in 1925 was an important step in keeping these communities independent from the City of San Diego to this day.

The other issue deferring the creation of a hospital district was a staff visit from the newly created Federal Veterans Bureau in the summer of 1922. Colonel Charles Forbes of the bureau (precursor to the Veterans Administration) visited San Diego with plans to locate a site for a large government hospital to treat tuberculosis and other ailments among the large number of World War I veterans. Although the bureau had an existing lease on the Camp Kearny site near E.W. Scripp's Miramar Ranch, it was not popular with the men and another site for San Diego was needed.

A few weeks later, the *La Mesa Scout* reported that Forbes had visited both the Grossmont site and another at Dr. Hymen Leichner's Alpine Sanatorium and was recommending the Grossmont site to his bureau superiors, including Dr. Sawyer, personal physician to President Warren Harding. Both the *Scout* and the *San Diego Union* reported on the potential $1.5 million facility, which was planned to hold five hundred disabled veteran patients. In a subsequently important side note, the article noted that the Federal Veterans Bureau was also considering sites in Arcadia and in west Los Angeles (eventual site of the new Veterans Hospital).

Even the San Diego City Council proclaimed its support of Grossmont as the site of the new government hospital. In July 1923, the bureau reported

that it would still consider the Grossmont site but not in the foreseeable future, unless Southern California needed another veterans' hospital. Another visit in October 1923 from General Frank Hines of the bureau kept some hopes alive. In the meantime, the U.S. Public Health Service contracted with the Alpine Sanatorium to care for government patients. Unfortunately, a year later, the patients filed many complaints against the Alpine staff, resulting in an investigation that ended the Alpine facility's contract in December 1924.

LOCAL PHYSICIANS MAKE NEW PROPOSAL

In May 1928, Ed Fletcher was again approached about donating land for a local hospital. This time, the proposal came from local East County physicians. Drs. Thomas Cunningham and Fred Walter of La Mesa represented other long-serving local doctors, including L.W. Zochert, Joseph A. Parks and C.E. Strite of La Mesa; Dr. C. Randall Knox of El Cajon; and Dr. Eugene Matthewson of Bostonia in presenting their proposal to Fletcher. Fletcher was once again amenable (being a contributor to other hospital campaigns, including Mercy Hospital). He offered five acres on the ridge just west of the struggling Grossmont Studios motion picture operation (near today's Anthony's Restaurant and the historical Alta Ranch pond).

Key to the doctors' proposal was an endowment fund to defray the hospital operations costs in addition to funds for buildings and equipment. Cunningham and Walter's statement explaining the purpose and structure of the hospital was published in the local papers in May 1928:

> *This will give everyone in this vicinity, especially the civic organizations, a chance to aid. We doctors do what we can but it is to be a general community hospital, non-sectarian and for service, not profit. The middle class man cannot afford to pay the price which an unendowed hospital must charge to make its expenses. This is a matter of great concern to the medical profession throughout the United States. We hope this community hospital at Grossmont will be endowed so that rates will be low enough not to work a hardship on patients.... This will not be a doctors' hospital, but a community hospital, erected to meet a definite need for service. We therefore are urging strong community support from all over the territory which it is expected to serve.*

In early June, the *La Mesa Scout* and *San Diego Union* reported on the plan for a new Grossmont community hospital. Site selection was considered the first priority. Fletcher reported that he needed to know soon if his offer is accepted so he could draw up the deeds. The hospital proponents sought $200,000 for their endowment. The committee's initial concept envisioned a fifty-bed non-sectarian general hospital that would meet the American Hospital Association's standards. The committee was a who's who of local businessmen and community leaders, including Mount Helix's Fred Hansen, chairman; Paul Fellows, Lemon Grove; A.W. Hall, Lakeside; John Haslam, La Mesa Heights (today's West La Mesa and College Area); W.D. Hall, El Cajon; L.G. Scott, Lakeside; and Colonel Fletcher. A $10,000 bequest from La Mesa pioneer Dr. Henry Porter reportedly got the campaign started.

Apparently, the onset of the Great Depression eighteen months later stymied the campaign and project. Although San Diego County was less affected than other areas of the nation, the Depression's economic and social affects were still significant—and the Grossmont community hospital was a casualty.

DEPRESSION BUSTS AND WARTIME BOOM

The economic challenges of the Great Depression required communities to look inward for support of social needs and causes. For La Mesans, two separate groups worked to address community healthcare and support such needs during the Depression years. Sarah "Nan" Couts quickly rose to be a leader in these efforts. Nan Couts, a native of England who had grown up in Fallbrook in north San Diego County, moved to La Mesa with her husband, J. Forster Couts of the pioneer North San Diego County family, in 1927. In the early years of the Depression, she organized efforts of the local Red Cross and San Diego County Welfare Department along with community service clubs and churches to help provide relief for local families in need.

In 1934, Couts helped create the La Mesa Welfare Association as the community vehicle for raising funds and delivering aid. As the Welfare Association's initial and long-serving president, she was a community leader of both vision and action. Typical of her efforts, later that year Couts worked with the State Emergency Relief Association (SERA)

to obtain a visiting nurse with government funding. The nurse, a Mrs. Stanton, was then on call to the Welfare Association to address cases of need at its direction.

At the same time, La Mesa also saw the opening of its own community hospital. Under the direction of registered nurse Sarah A. Carey, the La Mesa Sanatorium opened in 1928 on East Lemon Avenue—near today's intersection of Glen and Lemon. During the 1930s, the sanatorium continued to grow its operations. By 1937, a treatment ward had been added, and most considered the small facility a hospital. The local papers noted that the small private hospital was often the recipient of highway auto crash victims and growing popular as a facility for local births. As one of the few equipped medical care facilities, it also began to attract attention from local doctors in La Mesa, Spring Valley, Lemon Grove and El Cajon.

La Mesa Community Hospital Opens

With the rapid population growth during San Diego's prewar and wartime boom—growth that would double the county's population in four years' time—new owners ready to invest in expansion of the La Mesa facility arrived. In July 1943, new owner Edgar Hubbert, an engineer, and his wife, Dr. Ruth Hubbert, MD, of El Cajon, announced that the La Mesa Community Hospital, now fronting La Mesa Boulevard, was open for public visits and treatment. The new 50- by 150-foot building had been equipped with a modern kitchen, an emergency room, a surgery unit, an obstetrical department and a ward for small children. Mr. Hubbert reported that additional equipment had been purchased for a soon-to-be completed new wing. The small community hospital's opening was greeted with great excitement, as the boom had only exacerbated the shortage of hospital beds in the San Diego and East County areas.

In May 1944, La Mesa Community Hospital took a big step forward in organizing its medical staff with certified County Medical Society physicians. Surgeon Dr. B.J. O'Neill was named staff chairman; Dr. E.H. Calvert, secretary; Dr. Morton Carlisle, rules committee; and local legend Dr. C. Randall Knox, membership chair. In addition, doctors from San Diego, La Mesa, El Cajon, Lakeside, Chula Vista and La Mesa rounded out the staff.

In October 1944, Mr. and Mrs. Fern and Stella Cary purchased the hospital from the Hubberts for $60,000. Cary had been employed at the hospital since its formal opening in 1943. She reported that all graduate nursing staff would be retained, and Dr. Hubbert would continue her medical practice in El Cajon.

The La Mesa Community Hospital's expansion and reorganization were just the first steps in preparing for the oncoming exponential community growth that the peacetime baby boom promised. Soon, the growth would require similarly scaled hospital expansion to meet the rapidly growing community's healthcare needs. As the war would show with both Mercy and County Hospitals being overwhelmed and the navy's commitment to doubling its footprint in Balboa Park, the rest of the county would need to follow.

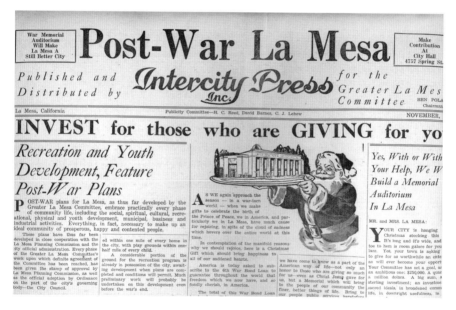

Greater La Mesa Committee Post-War Planning Newsletter, November 1944. *La Mesa Historical Society Archives.*

A MODERN HOSPITAL FOR EAST COUNTY

Booming San Diego County Sees a Need

The *Saturday Evening Post* called it San Diego's "Blitz Boom" in July 1941. San Diego's defense industry, led by Rueben Fleet's Consolidated Aircraft, was drawing in thousands of new workers in addition to U.S. Navy and Marine Corps recruits preparing for the United States' potential entry into the world war. San Diego's city and county populations would double in three short years, going from 203,321 (city) and 289,348 (county) in 1940 to 390,000 (city) and 500,000 (county) in 1943. San Diego civic leaders, as well as federal and regional planners, recognized the need for massive infrastructure improvements to support both the growing population and strategically important military-industrial complex. Water shortages in 1944 only confirmed the need to bring Colorado River water to San Diego, forcing the county's annexation into Southern California's Metropolitan Water District.

With access to this new water supply, the constraints on San Diego's suburban growth lifted. Funding for roads and infrastructure soon followed, and suburban sprawl swept over the mesas and valleys to accommodate those wishing to live the American Dream San Diego style. As early as 1944, San Diego civic leaders recognized that there was no turning back to the sleepy navy town of the interwar years. The San Diego Chamber of Commerce published a 1,500-page report commissioned from Philadelphia planning consultants Day and Zimmerman on the challenges awaiting the region in industry, housing, utilities, transportation, healthcare and education.

East County leaders also recognized that the war boom was affecting their previously small-town, rural communities. La Mesa's population would grow from 3,925 to 10,946 in 1950 and 30,000 by 1960. Similarly, El Cajon would jump from 1,471 to 5,600 during the 1940s, with an even more exponential jump to 37,618 by 1960. Similar to San Diego, East County leaders also began to plan for this inevitable postwar growth. La Mesa mayor Benjamin Polak formed the Greater La Mesa Committee in late 1943 to help plan and prepare for the coming changes in infrastructure, housing and recreational facilities for the small municipality.

In 1946 and 1947, the staggering need for housing in swollen San Diego was compounded with the equally swelling increase in births both nationally and locally. Birth rates soared as both older adults who had postponed marriage and family life during the Great Depression and World War II were joined with younger couples ready to start families. Subsequently, the La Mesa–Spring Valley School District, Cajon Valley School District and Grossmont Union High School Districts undertook planning efforts to address their ability to fund and build multiple new campuses to accommodate their already overcrowded facilities for the coming student populations.

East County's Hospital Needs Outweigh Capacity

East County civic leaders', physicians' and residents' desire for their own modern hospital, a twenty-five-year-long dream, was now even more in the forefront of the community's needs. In 1945, East County's estimated population of seventy thousand had no adequately sized or equipped hospital. For those in need of acute or specialized medical care, the small thirty-four-bed La Mesa Community Hospital or making the trip to Mercy Hospital ten miles away were the options.

Initial efforts focused on expanding the La Mesa Community Hospital. In August 1946, Stella Cary reported that expansion was desperately needed, as the hospital had exceeded its rated capacity. Cary commented that as the only hospital between San Diego and El Centro along U.S. 80 and the most direct hospital provider to East County's growing communities, the small facility had already undertaken over two hundred surgeries and one hundred births since the first of the year. As such, the recently installed and expensive X-Ray machinery and incubators were at capacity. With the hospital a

LA MESA, CALIFORNIA, THURSDAY, DECEMBER 27, 1951

NURSES FIND CROWDED WORKING CONDITIONS

TYPICAL OF THE INCONVENIENCES caused by the overcrowded conditions at the La Mesa Community Hospital is this bottleneck caused by nurses attempting to check patients' progress charts. This spot, located in the main corridor, is often congested with doctors, nurses, visitors, and patients being wheeled from one room to another.

Overcrowded La Mesa Community Hospital, 1951. *La Mesa Scout, La Mesa Historical Society Archives.*

participant in the government's Blue Cross program, much treatment to the large number of veterans and dependents was only reimbursed at cost. Cary and her staff felt that a one-hundred-bed facility could easily be supported regionally; a new lab room was under construction and bids for expansion of patient rooms underway.

Two months later, the Carys leased the hospital to Bert Arrington, former manager of the Balboa Naval Hospital. F.E. Heflin was to be the new manager and superintendent of the full-to-capacity hospital. One month later, the Carys sold the hospital on option to Arrington. Janet Johnson, former head of nursing at Mercy Hospital, was to be in charge, with Dr. A.E. Clark serving as the head of the medical staff. The new owners also announced plans for an expansion to one hundred beds.

FEDERAL AND CALIFORNIA GOVERNMENTS LAY THE PATH

The struggles of the small, private La Mesa Community Hospital were endemic to the healthcare challenges facing smaller, rural and rapidly suburbanizing communities. The federal government recognized and acted on the nation's needs for funding new community hospital facilities after the war. The Hill-Burton Act of 1946 opened up federal funding for modern hospitals to all communities. Hill-Burton, also known as the Hospital Survey and Construction Act, authorized some $75 million to be granted or loaned for construction of hospitals and related healthcare facilities nationwide. Taking direction from both the American Medical Association and American Hospital Association, the law recognized the establishment of a standard of four and a half hospital beds per one thousand residents. The act also required states to survey their hospital needs in order to prioritize funding to the most effective and worthy locations.

California lawmakers had been following this federal legislation since its initial introduction in 1945. Recognizing the demands being placed on California healthcare providers, both public and private, along with the needs of returning veterans and dependents in need of healthcare, the legislature enacted the California Local Hospital District Law into the State Health and Safety Code in 1945. The Local Hospital District Law provided communities with a locally controlled government entity that could impose property taxes, purchase property, issue debt, hire staff and operate hospitals and healthcare facilities. The main intent was to provide a source of funding, separate from cities and counties, that could be used to create publically owned community hospitals in rural or underserved areas. Typical of the time, these funds would also enable these hospital districts to recruit doctors and support their practices in order to get their participation.

San Diego County physicians and healthcare advocates quickly responded to this unprecedented opportunity. These were the laws that East County healthcare visionaries had hoped for back in 1921. Therefore, when the state offered funding for a comprehensive countywide survey of hospital needs in 1947, the San Diego Medical Society joined in support. The society wrote to the county supervisors in support of undertaking a desperately needed impartial survey of the hospital situation in the county in order to take full advantage of these new public funding opportunities. The survey results reinforced the severe shortage of hospital beds in the

county and also called out the efforts of East County's Suburban Hospital Association in funding and constructing a new hospital in the La Mesa–El Cajon area.

SUBURBAN HOSPITAL ASSOCIATION

Several months prior to the County Medical Society making its request to the Board of Supervisors in December 1947, a group of like-minded East County civic and community leaders had met to consider options for obtaining a modern community hospital. On July 19, 1947, William Bain, a vice president of the El Cajon Valley Chamber of Commerce, organized a meeting with a small and select group of local civic and community leaders to address the hospital issue. The ad hoc group recognized the need for further study of the issue and planned for several public meetings to be held.

Under the auspices of the El Cajon Chamber's Public Activities Committee, the first meeting was held on August 18, 1947, at the Grossmont High School Auditorium. Dr. P.K. Gilman of the California Department of Health spoke on the need for adequate facilities, noting that only .5 hospital beds were available for each one thousand residents of East County—and that formation of a local hospital district would be the community's chance at state and federal funds. At the meeting's conclusion, master of ceremonies Raymond Tuttle led the group of nearly two hundred representatives from local civic organizations such as the Rotary, Kiwanis and Lions Clubs to voice unanimous support to move forward to obtain funds for a comprehensive survey and analysis of the situation.

The newly anointed Hospital Survey Committee quickly held two more meetings: September 5 at the La Mesa Women's Club and September 22 at the El Cajon Baptist Church. At the last meeting, the organization was renamed the Suburban Hospital Association (SHA), with Raymond Tuttle as chairman and La Mesa Welfare Association president Nan Couts as vice chair. (William Bain was also a member of the San Diego Water Authority and soon became involved in the merger with Metropolitan Water.)

For the next year, the SHA moved forward slowly. Part of the challenge was the competing interest of several other groups, including the La Mesa Community Hospital. A for-profit company named Associated Hospitals Inc. had taken over the small hospital in early 1948. Apparently, this partnership did not work out, and the hospital was losing money. In October 1948, a new

nonprofit group named the La Mesa Community Hospital Association took over operations. The six-person board of directors featured local physicians Dr. Robert Cloyes, Dr. Harold Pfeiffer and Dr. William Soldmann; former owner Stella Cary; and veteran hospital administrator John Gorby and his brother William Gorby. John Gorby was to serve as hospital administrator. Their goal was somewhat similar to that of the SHA, gathering support from the local business, social and welfare associations of the area—but for improving the existing La Mesa Community Hospital.

Two weeks later, in early November 1948, the Suburban Hospital Association called on the Board of Supervisors to take action on the call for an independent survey from a third party to properly assess the county's true and unbiased hospital needs. Chairman Tuttle's letter noted the similar survey call from both the County Medical Society and Welfare Council in order to avoid the "multiplicity of hospital plans that are mushrooming without regard for long-range countywide needs." On February 19, 1949, the SHA met at the La Mesa Congregational Church to hold a public meeting to gain input on which path to follow—expansion of the La Mesa Community Hospital or a new public hospital. Two weeks later, the La Mesa Community Hospital Board, led by Dr. Cloyes, held its own meeting to discuss the issue, expanding the existing thirty-four-bed La Mesa Boulevard hospital or considering an offer of a seven-and-a-half-acre site in El Cajon for a new seventy-five- to eighty-five-bed hospital. The new La Mesa Community Hospital Board then established its own Hospital Site Selection Committee to consider the question.

On July 30, 1949, the Suburban Hospital Association and La Mesa Community Hospital Board and its Site Selection Committee met together to assess the El Cajon site offer and steps forward. Co-chaired by Dr. Cloyes, Dr. Soldmann and Raymond Tuttle, the group reportedly approved the actual five-acre site at Chase Avenue and Pine Drive in the Grossmont foothills for a new $500,000 sixty-bed facility that would replace the La Mesa hospital. The three-headed committee also retained Harry Freyburg and Rupert Linley as legal council to the project. The name Heartland Memorial Hospital was suggested to show the regional nature of the proposal.

Two weeks later, two new site offers provided the newly established executive committee of Dr. Cloyes, Ray Tuttle, Rupert Linley, Mildred Gilliland and Nan Couts with another challenge. The City of La Mesa offered an eleven-acre site between El Cajon Boulevard and the Alvarado Freeway under construction just east of Guava Avenue. Additionally, the Ed Fletcher Company returned to its 1920s offer of a seven-acre site just east of Grossmont High School—with already installed utilities—overlooking El Cajon Valley.

The Hospital Site Executive Committee realized that the decision required additional input from its constituent groups. Both met on August 30 to consider all three sites. The Suburban Hospital Association met and recommended accepting the Fletcher site. The La Mesa Hospital Board, however, acknowledged that a new public meeting, the first in nearly nine months to consider these sites—and some newly proposed locations—was needed.

In addition, both groups recognized the need to not only recommend a site but also create a single, permanent organization to carry the community hospital proposal forward. Three days before the September 16, 1949 public meeting at Grossmont High School, the Suburban Hospital Association agreed to incorporate into the La Mesa Hospital Association. The La Mesa Hospital quickly moved to re-constitute itself with a new board of directors. By the end of September, a new board consisting of Dr. Pfeiffer of La Mesa; George Caffee, El Cajon banker; Rupert Linley, Lakeside attorney; Carlyle Reed, publisher of the El Cajon and La Mesa newspapers; and Ray Tuttle, El Cajon businessman, now joined board holdovers Dr. Cloyes, Dr. Soldmann, Mr. and Mrs. William Gorby, Mr. and Mrs. John Gorby and Stella Cary.

The decision to follow the La Mesa Community Hospital's nonprofit structure was due to the recent good news that the once financially struggling institution had been certified by the American College of Surgeons. Dr. Lucious Johnson, ACS reviewer, noted that the staff of strong local general practitioners and professional administration had stabilized the hospital and made it self-sustaining for the first time.

The Grossmont Hospital Association

The La Mesa Hospital site selection committee continued to assess the various properties in the final months of 1949. Although the sites in La Mesa and El Cajon had several benefits, in December, the site selection committee recommended the Ed Fletcher Company site adjacent to Grossmont High. In the meantime, the board also moved forward to incorporate a new nonprofit corporation to be called, aptly, the Grossmont Hospital Association Inc. (GHA). Its main purpose was to oversee the funding and construction of the new hospital.

In February 1950, the GHA was incorporated. El Cajon insurance broker Richard Mills served as the first president, with Raymond Tuttle as vice president. Nan Couts and other SHA members continued serving with the newly formed organization. The Grossmont Hospital Association moved forward on several fronts. The first was getting the hospital survey completed; the second, confirming the final site; and the third to establish the appropriate vehicle for funding, building and operating the hospital—and how much it would actually cost to do so.

For much of 1950, the Grossmont Hospital Association worked behind the scenes to complete the studies and develop the plan. As such, the association added new and influential leaders to its organization. Burton Jones was one of the most important of those individuals. Jones, an experienced theater and entertainment man, had come to East County in 1941. In 1942, he purchased the La Mesa Theater and, recognizing the need for a new and exciting venue, contracted with nationally renowned theater architect S. Charles Lee to design the Helix Theater on La Mesa Boulevard (opened 1948). He quickly became a leader of the La Mesa Chamber of Commerce, president of the La Mesa Rotary and an active promoter of the city and region's businesses. A talented and tireless promotions man, Jones became the public face and spokesperson for the GHA during these foundational years.

Consultant studies dominated the remainder of 1950 into early 1951. A key element to the success of the GHA's efforts was its planning team of

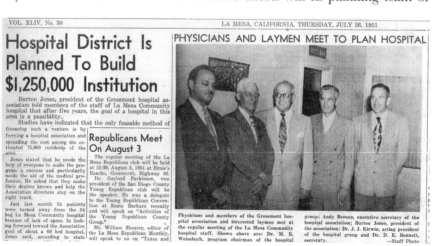

Hospital District plans revealed, 1951. *La Mesa Scout, La Mesa Historical Society Archives.*

experienced physicians and hospital professionals with local businessmen, contractors and community representatives. In July 1951, GHA president Burton Jones announced the results of the studies and the association's subsequent plan for action. The studies had indicated that the formation of a public hospital district was the only feasible method for financing the hospital. Association secretary Andy Benson reported that considering the state standards for hospital facilities, initial estimates of size and cost for a modern, compliant hospital for the region had risen to $1.25 million. The first step was therefore to create the district, and time was of the essence. If the district could not be established before January 31, 1952, the association would lose an entire year toward funding and construction.

Burton Jones quickly instituted a program to gather the necessary four thousand signatures for the petition to hold a special election to create the local hospital district. In August 1951, the San Diego County Boundaries Commission approved the ambitious plans for the 700,000-plus-acre district that encompassed the southeast quarter of the county. Jones then oversaw a campaign to gather petition signatures and hold a public hearing in November to ensure a January election. In November 1951, the petition was presented to the GHA Board of Supervisors for approval. Although some areas requested to be excluded, only the then unincorporated Rolando area, adjacent to San Diego but not in City of La Mesa, was left out of the original proposed district boundaries.

The board approved the petition and scheduled the special election for January 8, 1952. Burton Jones led the campaign with well-placed articles and advertisements in local papers, effective mailers with convincing testimonials and presentations to local civic and community groups by key religious,

TO PETITION SIGNERS

TUESDAY, January 8, 1952 is Election Day to form the Grossmont Hospital District.

We know you will vote yes.

We urge you to enlist the members of your family, your neighbors, your friends to vote "YES."

Then ask each one to enlist five more votes in the "Yes" column.

We need a hospital now, even more than six months ago.

Thanks in advance,

BURTON I. JONES, President
Grossmont Hospital Association

District campaign postcard, 1951. *GH Collection.*

51

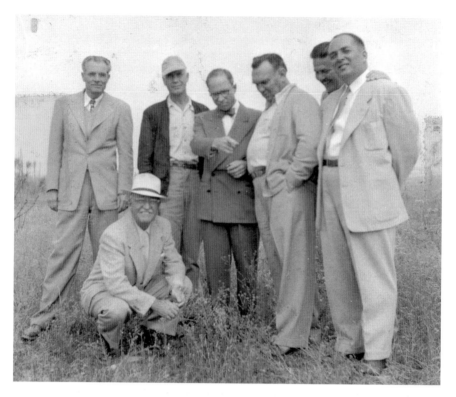

District Hospital Site Selection Committee investigating newly proposed location, 1952. *GH Collection.*

political and healthcare leaders. Jones and the committee presented a clear message. With the possible cost of the hospital being over $1.2 million, only a state-sanctioned public hospital district with its taxation and bonding ability could cover the costs of such a modern institution.

On Election Day, volunteers manned over forty polling places established across the proposed district's boundaries, each open from 7:00 a.m. to 7:00 p.m. that day. Transportation and babysitting services were offered to ensure participation of all voters. The results were also clear. East County's voters overwhelmingly approved the creation of the Grossmont Hospital District by a vote of 3,835 to 1,030. The first step was now complete, but the next steps would be even more impressive.

BUILDING THE COMMUNITY'S HOSPITAL

THE DREAM TEAM

East County had made an essential and decisive step forward that January day in 1952. But it was just the first step toward what would be a whirlwind three and a half years to realizing the hospital. The creation of the district required the establishment of a governing board, funding the design, operational plans and construction of the physical plant prior to admitting its first patient.

As soon as the county certified the election, the GHA Board of Supervisors took the first action with appointment of five men to the initial Grossmont Hospital District Board. All were local leaders with needed expertise and talents. R. Marvin Jackson, homebuilder and contractor, was named president. Homer Streich, a retired businessman, became secretary. Stanley Andrews, owner of a sporting goods chain, was appointed treasurer. Real estate and insurance man Forace Boyd and former chairman Burton Jones rounded out the initial five-member board. Equally important would be the role for Nan Couts. The board tasked Couts with the creation of the Hospital District's Women Auxiliary Association.

In the spring of 1952, the new board quickly moved to build the administrative infrastructure of the district and obtain expertise for moving the hospital planning forward. The board members acted to find men experienced in hospital administration, finance and design. They held numerous interviews with other hospital administrators, consultants and architectural firms with hospital design experience.

In April, the board hired its most significant addition, Louis Peelyon. Peelyon was then the executive director of the San Diego Society for Crippled Children, which operated the Children's Convalescent Hospital. More importantly, he had helped establish local hospital districts in Brawley and Imperial as well as at Lompoc in Santa Barbara County. Peelyon had recently moved his family into the Vista La Mesa neighborhood in west La Mesa near Lemon Grove. Board president Marvin Jackson was quoted in the *La Mesa Scout* enthusing that "we are fortunate for Mr. Peelyon's advice and assistance, as we believe his knowledge will be invaluable to us."

Momentum for completing plans for the hospital accelerated when in early May both Jackson and Burton Jones attended the Western Hospital Association Convention in San Francisco. Upon their return, the duo reported in the *Scout* that the district's rapid formation and documented community need made the potential for federal and state funding much better than originally anticipated. Jackson and Jones remarked that meetings with officials of the Bureau of Hospitals of the State Department of Health of Public Health identified the new district as a "high priority" for funding.

The board then appointed a committee of doctors to consult on the design, structure and operational plans of the new hospital. Dr. Darwin Bennett oversaw the initial committee, including Drs. C.O. Tanner, Alpine; William Soldmann, La Mesa; E.H. Calvert, El Cajon; Harold Elder, Grossmont; Herbert Hughes, Grossmont; Howard Ball, Alpine; Wesley Herbert, Lemon Grove; and Harold Pfeiffer and Tim Richey of La Mesa. President Jackson noted the importance of local doctors who would be contributors to the hospital planning efforts.

The board announced the third but, arguably, the most important component of the planning team two weeks later—the architectural and engineering firm of Pereira and Luckman of Los Angeles. Both University of Illinois graduates, William Pereira and Charles Luckman had formed their firm two years earlier in Los Angeles, where Pereira had been practicing since the 1930s. Although both together and individually Pereira and Luckman would create hundreds of iconic projects over their careers (UCSB and UC Irvine campuses, Disneyland Hotel, Los Angeles International Airport Theme Building, to name a few), by 1952, they had become known as experts in hospital design. Pereira taught a hospital design course at the USC School of Architecture. Their award-winning designs for the Motion Picture Relief Fund and Nurses Home Hospital in

Los Angeles and the Lake County Tuberculosis Sanatorium and several additions to the Huntington Memorial Hospital in Pasadena made them the clear board choice over the other dozen firms considered.

LOCATING THE DREAM

With planning accelerated, the decision on final site selection was required. The board had assigned Homer Streich to oversee the site selection process, but as early as January, board members were having doubts toward the previously approved Fletcher site just east of Grossmont High School in the now suburbanizing Fletcher Hills. The board had also questioned original plans for a sixty- to eighty-bed hospital when studies and state officials called for a minimum one-hundred-bed facility with room for expansion. The Fletcher (seven acres) and El Cajon (five acre) sites, now surrounded with new home development, appeared to be restrictive to long-term needs.

Although those sites were being donated free of cost, the board looked to other properties to meet its growing long-term needs. The property that had drawn the most attention was just west of the Eucalyptus Reservoir (now La Mesa's Briercrest Park). San Diego's Levi family owned several large parcels

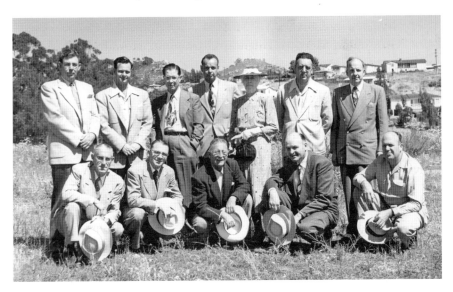

Grossmont District Board and Search Committee at Levi Property Site, June 1952. Homer Streich is third from left in front row. *GH Collection.*

in the area, and the board reportedly began discussions on acquisition of the easternmost thirty-five acres of the Levi property. The property was in the undeveloped lands north of the newly constructed U.S. Highway 80 La Mesa "bypass" that the State Department of Highways (CalTrans) was building to connect the Alvarado Freeway to Grossmont Pass (route of today's Interstate 8). Although the site was remote at the time and not directly connected via public roads, the board and its planning team realized that the City of La Mesa had recently annexed much of the area of the old nineteenth-century north La Mesa Colony tract and that several large developers were moving forward on developing the new "north city" lands. As such, in the summer of 1952, Streich and Jones began formal negotiations for the purchase of the Levi property. Later that year, the board completed the purchase agreement with the Levi estate for thirty-five acres for a reported $35,000. In a 1981 oral history interview, Burton Jones, who had made many a profitable business transaction, noted that the "best deal he ever made" was to purchase the Levi property for Grossmont Hospital.

PLANNING THE DREAM

By the summer of 1952, with a planning team moving forward and prospective government funding likely, the board and its team appeared to have all the pieces assembled. One of those key pieces was the district's women's auxiliary. At its July meeting at Grossmont High School, the board met with thirty-four women from throughout the district on the formation of a working auxiliary organization. These leaders voted in a temporary charter and board of officers, including the unanimous election of Nan Couts, original hospital committee member, as president. The remaining list of initial auxiliary board members included Mrs. Josephine Francisco, vice president; Mrs. Virginia Mitchell, secretary; Mrs. Elizabeth Marston and Mrs. Hazel Morath, El Cajon; Mrs. Jean Smiley, Lakeside; Mrs. Ethel Fellows, Lemon Grove; Mrs. Marian Daley, Jamul; Mrs. Ida Welch, Fletcher Hills; Mrs. Ercel Smith, Spring Valley; and Mrs. Evelyn Ball, Alpine.

The hospital board had passed onto the new auxiliary members the important role of helping to raise funds and awareness. Also relayed at this meeting was the news that a $1.3 million application for state and federal funding had risen from seventh to third on the state's priority list due to the district's efforts. If the application were forwarded, the district would once

again need to act on a planned $750,000 bond election within four months to raise the necessary matching funds locally.

Such a positive message on immediate funding for the now close to $2 million hospital was severely shaken—literally—with news from Bakersfield in Kern County six days after this meeting. On July 21, 1952, an estimated magnitude 7.3 earthquake hit the Bakersfield area, killing twelve, injuring dozens and severely damaging the downtown and its local hospitals. In early September, the State Hospital Advisory Board reprioritized California's federal Hill-Burton funding requests, bumping San Diego County's Grossmont and new nonprofit Sharp Memorial Hospital's applications for three other applications in quake devastated Kern County. John Gorby, La Mesa Community Hospital administrator and local member of the Hill-Burton Committee, reported on the unfortunate situation, which would likely merit a year's delay in reapplying for local priority candidates Grossmont and Sharp.

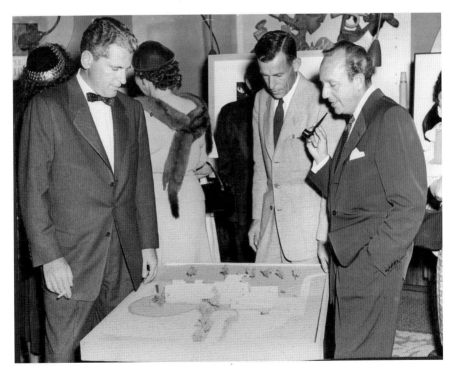

Charles Luckman, Marvin Jackson and William Pereira examine a hospital model at Helix Theater Open House, October 8, 1952. *GH Collection.*

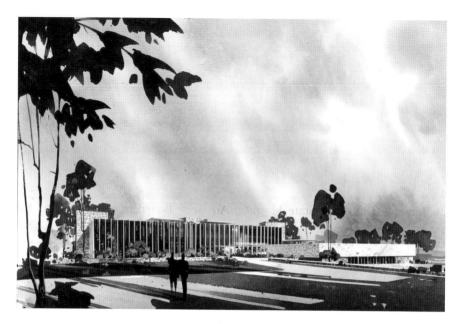

Pereira and Luckman conceptual sketch for Grossmont Hospital, October 1952. *GH Collection.*

Undaunted, the district continued to move forward. Pereira and Luckman completed conceptual plans and unveiled them in a public meeting held at Burton Jones's Helix Theater in La Mesa on October 8, 1952. Pereira and Luckman's design was illustrated in large graphics and a contour model. Over one hundred community leaders and residents, including many local doctors, nurses and auxiliary board members, attended and met with the two architects. The conceptual design indicated a plan for up to 133 beds initially, with multiple expansion opportunities. All in attendance reported positive responses to the modern structure's design. Board president Jackson was quoted in the *San Diego Union* that the district's planning efforts had "met many problems we didn't even know existed, but we are confident we are headed in the right direction." Homer Streich was even more hopeful. Streich posited that the possible funding delay could be less than a year and the district needed to move forward and be ready. He added that the district was in final negotiations for the purchase of the thirty-five acres of the Levi property in North La Mesa and that would be the site of the new hospital.

Shortly after this meeting, the first board election was held during the general election on November 10, 1952. The election confirmed the original supervisor appointments, with all five appointed board members

being elected by large margins in the formal election for their board seats. Members Jackson and Boyd drew the initial two-year "short terms" of the initial appointed members, while the others received full four-year elected terms. The district leadership's stability would continue to provide dividends.

Funding the Dream

Homer Streich and his board colleagues' confidence was soon rewarded. In January 1953, the State Hospital Advisory Board released its 1953 list for project funding, with Grossmont District assigned priority ranking. The district soon moved to prepare the campaign for the bond act to acquire the matching funds. Once again, Burton Jones's promotional skills would come to the forefront. But all district members would contribute. Nan Couts and the auxiliary helped with both spreading the word to women's clubs, parent-teacher associations (PTAs) and church groups, as well as through direct fundraising. Typical auxiliary community efforts included that of the Rolando Women's Club, whose members, such as Mrs. Jean Chadwick, recalled going "door-to-door telling people how much we needed a hospital." These efforts complemented events such as the auxiliary's Country Fair fundraiser at the El Cajon ranch home of auxiliary board member Mrs. Edward Morath and similar campaigns to establish endowments, including a tribute and memorial fund. All these efforts kept the hospital and its coming campaign on the minds of East County residents.

On August 21, 1953, when the State Hospital Board released its grants, the Grossmont District was ready. The district's application was one of the highest ranked of the 8 funded applications out of the 142 received. The State Board approved the grant for the $1.2 million request. All that was needed now was the matching funds.

Burton, Streich and the newly formed Citizens Committee launched into action with one of the best-orchestrated campaigns in support of the October bond election. The previous few years' promotions and public relations groundwork paid off handsomely. The broad base of constituents, which included churches, civic organizations, chambers of commerce, PTAs, political and business groups, women's organizations, medical professionals, welfare organizations and service clubs, all supported this communitywide effort. Perhaps never before or since has the East County community come together as it did that autumn in 1953.

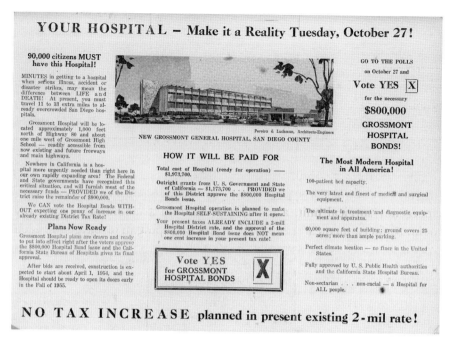

YOUR HOSPITAL – Make it a Reality Tuesday, October 27!

90,000 citizens MUST have this Hospital!

MINUTES in getting to a hospital when serious illness, accident or disaster strikes, may mean the difference between LIFE and DEATH! At present, you must travel 11 to 13 extra miles to already overcrowded San Diego hospitals.

Grossmont Hospital will be located approximately 1,000 feet north of Highway 80 and about one mile west of Grossmont High School — readily accessible from now existing and future freeways and main highways.

Nowhere in California is a hospital more urgently needed than right here in our own rapidly expanding area! The Federal and State governments have recognized this critical situation, and will furnish most of the necessary funds — PROVIDED we of the District raise the remainder of $800,000.

We CAN vote the Hospital Bonds WITHOUT expecting one penny of increase in our already existing District Tax Rate!

Plans Now Ready

Grossmont Hospital plans are drawn and ready to put into effect right after the voters approve the $800,000 Hospital Bond issue and the California State Bureau of Hospitals gives its final approval.

After bids are received, construction is expected to start about April 1, 1954, and the Hospital should be ready to open its doors early in the Fall of 1955.

NEW GROSSMONT GENERAL HOSPITAL, SAN DIEGO COUNTY

Pereira & Luckman, Architects-Engineers

HOW IT WILL BE PAID FOR

Total cost of Hospital (ready for operation) — $1,973,700.

Outright grants from U. S. Government and State of California — $1,173,700 . . . PROVIDED we of this District approve the $800,000 Hospital Bonds issue.

Grossmont Hospital operation is planned to make the Hospital SELF-SUSTAINING after it opens.

Your present taxes ALREADY INCLUDE a 2-mill Hospital District rate, and the approval of the $800,000 Hospital Bond issue does NOT mean one cent increase in your present tax rate!

Vote YES for GROSSMONT HOSPITAL BONDS [X]

GO TO THE POLLS on October 27 and

Vote YES [X]

for the necessary

$800,000

GROSSMONT HOSPITAL BONDS!

The Most Modern Hospital in All America!

100-patient bed capacity.

The very latest and finest of medical and surgical equipment.

The ultimate in treatment and diagnostic equipment and apparatus.

60,000 square feet of building; ground covers 25 acres; more than ample parking.

Perfect climate location — no finer in the United States.

Fully approved by U. S. Public Health authorities and the California State Hospital Bureau.

Non-sectarian . . . non-racial — a Hospital for ALL people.

NO TAX INCREASE planned in present existing 2 - mil rate!

Campaign flyer for October 1953 Bond Act Election. *GH Collection.*

On October 27, 1953, the voters of the Grossmont Hospital District voted 8 to 1 (7,803 to 1,020) to authorize the $800,000 bond measure. Every precinct passed the measure by at least 2 to 1. Marvin Jackson commented in the *Union* on the "sense of deep humility to realize how many people are behind us in this work." Campaign leader Burton Jones also called out the efforts of Couts and the women's auxiliary as well as the active Citizens Committee that was formed to help promote the district. Jones noted these groups "not only got out the information on the hospital but they also got out the vote." Nan Couts, the only remaining original committee member from 1946, made this concise statement: "It was a dream come true."

DESIGNING THE DREAM

In the meantime, Pereira and Luckman continued to prepare the detailed construction bid package. The design of the new hospital would be not only modern in style but also state-of-the-art in hospital design and equipment.

The architects' key design concept placed the clinical and diagnostic departments and the medical supply in a centralized core. The core then served the surrounding surgical and delivery departments as well as the outpatient services grouped around it. From a central core, the rest of the hospital operations could then be supported through the system of elevators and dumbwaiters, allowing transfer of staff and supplies to the patient and nursing wards. Pereira and Luckman's hospital arrangement created efficiencies in operations—and construction cost savings.

The nearly sixty-thousand-square-foot hospital would include two surgery rooms, a "fracture room," a cytoscopic surgery room, an emergency surgical unit, a recovery room and a laboratory and X-ray room. Modern medical features included the piping in of oxygen to each patient room. The maternity ward—expected to be the busiest department of the hospital—was to be on the first floor with its own entrance to help reduce congestion with less busy department areas. In addition, the growing emphasis on medical specialties called for development of a separate pediatrics ward and surgery rooms.

The hospital plan also included a coffee shop for visitors, a medical library and a fully staffed commercial-scale kitchen and dining room expected to serve over 120,000 meals per year. Its cantilever construction style with two central support structures through the center of the building and extended framework allowed for lighter, nonstructural façades. This modern structural design therefore provided a more open floor plan that would allow expansion of the hospital in three directions. This was key considering the current plan was sized to meet the needs of a community of 114,000, the expected size of the district for its late 1955 opening, while allowing for future growth from 100 to 250 beds if needed.

Building the Dream

Pereira and Luckman's cutting-edge plans and specifications were submitted to the state fire marshal, State Board of Hospitals and federal hospital inspectors for review in early February 1954. It was a busy month. Two weeks later, at a ceremony after the monthly board meeting, the district bonds approved in October were signed and released for sale to the market. The board also confirmed the hiring of Louis Peelyon as consultant for oversight of the construction and staff organization of the hospital. Burton Jones and

Homer Streich then traveled to Los Angeles to ceremonially accept the two $586,687 grants from the state and federal governments.

On March 1, 1954, the district hired its first administrative assistant, Nellie Smith, and rented a temporary office at 8123 La Mesa Boulevard for Peelyon, construction manager Everett L. Jones and the board to oversee the expected fourteen-month construction period. A few days later, the district released the approved plans for bidding with an opening date of April 5, 1954. Trepte Construction Company of San Diego was the low-bid general contractor, with major subcontractors Ham Brothers of El Cajon for utilities and Daley Company for grading. Plans called for construction to start in early May. In late April, the board met to sign over the sale of the bonds to the purchasers, Bank of America.

On April 27, the district held a groundbreaking ceremony to celebrate the start of construction. Marvin Jackson and Nan Couts spoke on the great progress made in such a short time. Couts, as the longest standing member of the original committee, was to break the ground with the ceremonial

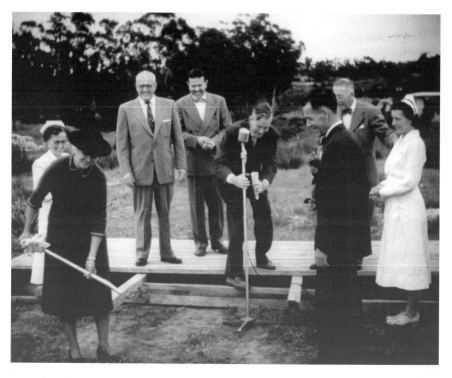

Nan Couts breaking ground for the new hospital with the board present, April 27, 1954. *GH Collection.*

shovel. The only tempering aspect was the resignation of Burton Jones from the board. Jones had recently moved to San Diego to oversee his renovation of the old Egyptian Theatre on Park Avenue as well as several other business ventures. The board quickly appointed Ralph Peterson, a Grossmont resident, San Diego businessman and key member of the Citizens Committee during the bond campaign, to fill Jones's seat.

That November, the first truly contested board election was held. Incumbents Andrews, Streich and Peterson were running for reelection, with four additional candidates joining the race. The November 3, 1954 election produced new terms for Andrews and Peterson, but surprisingly, former hospital administrator Herbert Burrell secured the third spot ahead of Homer Streich. *La Mesa Scout* editor William James Hill found the result regrettable considering Streich's significant efforts to make the hospital idea a reality, citing ballot placement as a possible culprit. In February 1955, the board appointed Streich to the newly created position of district treasurer.

The Grossmont Hospital project moved forward as the City of La Mesa and San Diego County Planning Commission approved plans for development of the old "La Mesa Colony" properties north of U.S. 80 (often called North La Mesa). The La Mesa Planning Commission also approved the plans for the Department of Transportation's new Jackson Street underpass. The city council promised $260,000 for street improvements that would provide an outlet for a new direct-access road to the hospital from the Jackson Street extension and freeway interchange. In June 1954, the City of La Mesa annexed the hospital property into the city limits.

The record planning, design and funding schedule was also followed with a similarly rapid construction period. Trepte Construction started work in May 1954. By July, progress was such that passersby saw walls rising from the new foundations. In October 1954, Peelyon and Everett Jones announced from their new office—a small A-frame structure dubbed "The Tepee"—that the project was already 40 percent complete, ahead of schedule and under budget.

Work did stop in late December 1954 when several trade unions shut down the hospital construction in support of a roofing worker's dispute. After a court-ordered labor settlement, the weeklong stoppage ended, construction restarted and the project moved forward—still ahead of schedule. In April 1955, with construction near completion, a dedication event date of July 24, 1955, was set. The hospital would open in August.

In the meantime, Louis Peelyon's efficient work to manage the hospital's planning and construction and his expertise in hospital management led

Above: Dr. William Soldmann, unidentified and Louis Peelyon examine new lab equipment, 1955. *GH Collection*.

Opposite, top: Construction manager E.L. Jones and Louis Peelyon reviewing plans within the "tepee" construction office, 1954. *GH Collection*.

Opposite, bottom: E.L. Jones, Ellie Smith and Louis Peelyon erecting a sign on the new hospital building, spring 1955. *GH Collection*.

the board to what many had assumed. In late 1954, the board hired him to become the first permanent Grossmont Hospital administrator. Peelyon went right to work preparing operations for the nearly complete hospital. Soon, Peelyon was building both an administrative and medical staff. He hired Hugh McDaid of Fletcher Hills to serve as full-time chief engineer. McDaid had worked with Peelyon at Pioneer Hospital in Brawley and had consulted on the unique design of the steam power unit and emergency backup systems.

During that spring of 1955, Peelyon coordinated the rapid buildup of staff and equipment necessary to open and operate. He led the hiring of the nearly 150 employees needed for the new hospital. Grossmont Hospital's expected monthly payroll of $46,000, with $20,000 monthly budget for purchasing supplies, was quickly recognized as an unparalleled economic benefit for the region. Peelyon presented the board with detailed operational plans, manuals and organizational charts to guide the hospital's business, operation and chain of command structure. In April, the board approved a list of sixty-five physicians to the hospital medical staff. Dr. William Soldmann was chosen as the first chief of staff and Arelia Kelly, RN, as director of nursing.

In addition to the growing administrative and medical staffs, the women's auxiliary led the way in building the hospital's community support and

Women's Affairs

INVITATIONS COMMITTEE—Women of the Grossmont Hospital Auxiliary invitation committee last Friday mailed out 750 invitations to the "Harvest Ball." The event will be held at the El Cortez Hotel on Oct. 1. Proceeds will go to the Auxiliary's landscaping fund. Seated around the table, starting at the left, are Mmes. Ralph Peterson, co-chairman, Walter Settles, James Henderson, Henry M. Miller, Jr., Paul A. Schoonhoven, Harold Elden and Franklin Orfield. —Staff photo by Dick Sims

Grossmont Hospital Women's Auxiliary prepares for annual Harvest Ball fundraiser event, 1955. *GH Collection.*

Homer Streich and Nan Couts at the sundial monument honoring work of Couts and the women's auxiliary, July 24, 1955. *GH Collection*.

volunteer programs. The auxiliary engaged in recruiting and establishing indoctrination and training courses. It also prepared to staff the hospital gift shop, with proceeds to support the auxiliary's efforts. The women held their second annual Country Fair fundraiser event at La Mesa's Lemon Avenue School and helped coordinate donations of funds and equipment from various regional service organizations, including the Bostonia, Suburban Hills and La Mesa Women's Clubs; Fletcher Hills and El Cajon Lioness Clubs; Wintergarden's Brownie troop; Foothills Arts Association; El Cajon Elks Club; La Mesa Rainbow Girls; and "Contrib" Club at Convair Aircraft.

DEDICATING THE DREAM

On July 24, 1955, the Grossmont Hospital District held a dedication ceremony and open house for its new, modern facility. The hospital's physical plant was complete, and only installation of equipment and furnishings remained. It was a time for both reflection on past efforts and a look to a future of community service. The Sunday afternoon event featured the return of Burton Jones as master of ceremonies. Dr. Malcolm Merrill, state director of public health, was the featured speaker. Reverend Dan Apra of Lemon Grove and Pastor Dennis Barry of St. Martin's Church in La Mesa provided dedication prayers. Homer Streich and Nan Couts providing some historical background. Architect William Pereira also provided brief remarks on the hospital's design and construction for the crowd. Pereira noted that any success could be traced to the cooperation his team received from the board and contributors that allowed for creating a hospital seeking a better way to serve the needs of the people.

As Louis Peelyon noted, nearly everyone in the entire district had, or would have, a part in making possible this institution. Peelyon was quoted in the local papers that his only regret was not being able to thank all those individuals and organizations who had contributed. He added, "We of the staff and the members of the board of directors feel privileged and honored at being permitted to carry out some of the dreams and aspirations of the people of the Grossmont Hospital District."

The dedication day's festivities reflected those community-wide efforts. The Grossmont High School summer school band provided music, local Boy Scouts served as color guard with National Guard Reserves for parking and traffic control and Hospital Auxiliary volunteers serving as

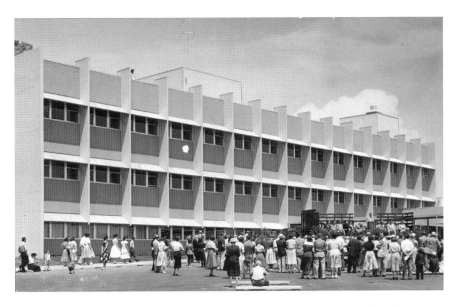

Crowd gathered at portable stage for hospital dedication, July 24, 1955. *GH Collection.*

Board member Forace Boyd and Grossmont nurses congratulate Walter Trepte, general contractor, for completing construction, July 24, 1955. *GH Collection.*

Initial nursing staff gathered in Grossmont Hospital's cafeteria, July 1955. *GH Collection*.

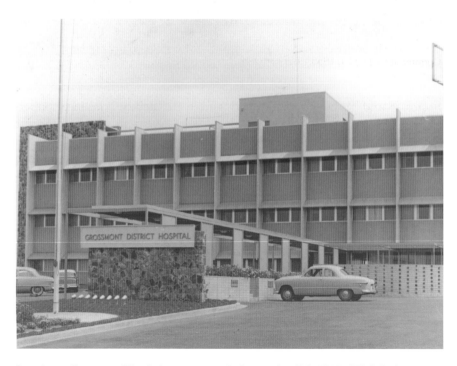

Brand-new Grossmont Hospital entrance ready for opening, July 1955. *GH Collection*.

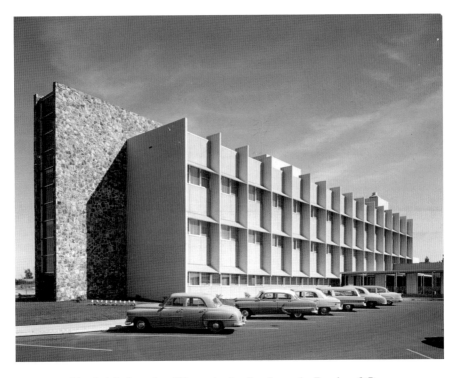

Grossmont Hospital dedicated to "Humanitarian Service to the Peoples of Our Communities, July 24, 1955." *GH Collection*.

hostesses and guides stationed throughout the facility. The local papers reported that approximately 1,500 community members attended the dedication and an estimated 7,000 more toured the hospital during the following open house week. Visitors followed a set of red arrows marking the tour route past manned stations, ending in the cafeteria, where auxiliary members served refreshments.

In honor of Nan Couts's efforts in the creation of the district and auxiliary organizations, the auxiliary presented the hospital with a sundial to be placed as a monument in the hospital courtyard in her honor. A teary-eyed Couts was quoted in the *San Diego Union* that it had been eight years and five days since the first meeting to create the hospital. She commented that the sundial was "appropriate since it marks time, the healer of all things." She added, "It will always be here to remind all of you good citizens of what you have done, with God's help, to make this dream come true."

4

GROSSMONT HOSPITAL DELIVERED

DELIVERING THE PROMISE

Grossmont Hospital, East County's symbol of community pride and accomplishment, had been delivered. From an over thirty-year desire to obtain a community hospital to the focused and whirlwind eight-year campaign to turn the hospital idea into reality, the new and modern-in-every-way institution had only to provide the service promised. The Citizens Committee, which had been so instrumental in the campaigns for the bonds, made its last act the donation of furnishings for the director's board room.

Official opening day was scheduled for August 15, 1955. Last-minute preparations continued up to the planned 7:00 a.m. opening. Administrator Peelyon put together an experienced administrative staff. In addition to administrative secretary Nellie Smith were Claude Dooley (controller), Arelia Kelly (director of nurses), Mabel Rice (dietician), Richard Van Dusen (pharmacist), Jeremiah Crews (maintenance superintendent) and Hugh McDaid (chief engineer).

Chief of Staff Dr. Soldmann headed the list of initial active physicians formally aligned with the new hospital: Drs. Howard Ball (hospital pathologist), Chester Barta, Robert Cloyes, Harold Elden (vice chief), J.C. Flaniken (radiologist), Wesley Herbert, James Higgins, Purvis Martin, G. Roger Myers (secretary), Sam Peck, Harold Pfeiffer, Marshall Persky, Tim Rickey and Chester Tanner, many of whom had been involved in the planning of the hospital. Over the following months, the self-governing

WELCOME TO GROSSMONT

"Welcome to Grossmont." Grossmont Hospital brochure, 1956. *GH Collection.*

medical staff would approve dozens of additional associate, consulting, courtesy and honorary doctors for Grossmont.

The growing number of physicians was matched by the highly qualified nursing staff. Director Arelia Kelly had also prepared her nursing staff for that much-anticipated opening day. The hospital opened with forty-four registered nurses, graduates of thirty-five separate nursing schools. The challenge of finding qualified graduate nurses in the growing hospital industry was illustrated in the fact that many of these professional ladies came to Grossmont from states as far away as Massachusetts, Rhode Island, New York, Kentucky and New Mexico. California native Kelly noted that

This is
YOUR
HOSPITAL

SURGERY AND LABORATORY

MATERNITY CARE

MEMBERS OF THE STAFF

HOSPITAL FLOOR PLAN

GROSSMONT HOSPITAL
La Mesa, California

"This Is Your Hospital," Dedication Day brochure cover, July 1955. *GH Collection.*

the hospital felt privileged to have such a highly qualified staff. Typical of the time, since most were married women—as was Kelly—no nurses' quarters would be required.

Busy Opening Day—and Year

Of course, not everyone could wait for the doors to open. On that fateful Monday morning, at 6:10 a.m. the hospital admitted Mr. and Mrs. Rudolph Callas and their doctor, George Brown Jr. of El Cajon. The Callases' son, Randy, turned out to be the anxious one. Luckily, night watchman J.H. Sluder contacted controller Claude Dooley, who phoned administrator Peelyon, who alerted the duty nurse and provided assistance for Dr. Brown to deliver eight-pound, three-ounce Randy George Callas at 6:26 a.m. The Callases were rewarded with special gifts from local merchants for their fourth child, including a bassinette, six months' supply of baby food, a baby scale, a year's supply of baby oils, baby clothes, a photo gift certificate, roses and twenty dollars in hair dressing for the mother. Randy's arrival beat the runner-up by two hours, Dr. and Mrs. Robert Cloyes's daughter, born at 8:27 a.m. All in all, Grossmont Hospital day one saw twenty-four admissions, including four surgeries and five births.

Less than one month into operations, Administrator Peelyon reported to the board that the hospital was already running at staffed capacity. Although the hospital now employed 157 permanent staff, allowing for an estimated 75 percent capacity, 327 admissions had occurred, 54 babies were delivered and 100 major and 37 minor surgeries performed. He expressed satisfaction at the new staff's performance as well as that of the in-hospital volunteer aides, in their cherry-colored uniforms, supplied through the women's auxiliary. Confirming the perceived demographics of the baby boom, Peelyon noted that he and the administration concurred with local pediatricians in recognizing the need to establish a fully functioning twenty-four-hour, seven-day-a-week pediatric unit.

The hospital being at capacity and in need of immediate growth was a common theme for the first year of operation. Growing hospital staff continued to keep up with the needs and demands of the medical staff, patients and physical plant. As the young hospital closed in on its first anniversary, the new institution's report card was impressive. In December 1955, State Hospital Bureau auditors confirmed the final hospital building

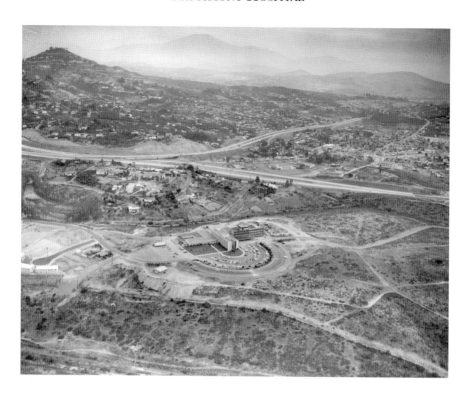

Above: Aerial view of new Grossmont Hospital, 1955. The only paved access road is from Wakarusa Street (*left center*). *GH Collection.*

Left: "Grossmont Capsule, April 1956." Newly named staff newsletter with iconic sketch of hospital. *GH Collection.*

and equipment cost at $1.7 million. They also found that the final costs were below estimates, identifying efficient design and construction management. Although questions had surfaced from taxpayer critics during the first fiscal year, the final books showed the operation approaching its first anniversary fully solvent and showing a profit.

At the one-year anniversary, Grossmont Hospital boasted a staff of 361 physicians and surgeons along with 31 dentists and had averaged treatment of 70 patients daily in the 108-bed hospital. Hospital admissions totaled over 6,000 patients. The maternity department alone delivered 1,009 babies in that first year.

A COMMUNITY AND REGIONAL ASSET

Two months earlier, in May 1956, Grossmont Hospital held a healthcare open house, along with the La Mesa Community Hospital—still operating as a nonprofit hospital under guidance of experienced administrator John Gorby. Louis Peelyon used the open house to both answer questions on the new hospital's functions and explain that the board and staff were already considering expansion of both staff and facilities.

now, about
VISITING...

Some facts of importance to patients, their families and friends from
GROSSMONT HOSPITAL

"Now, About Visiting…" Visitor information brochure, 1955. *GH Collection.*

The administration and staff had clearly proven themselves as both community and regional assets. Grossmont's success had led North County's Tri-City Hospital District to identify Grossmont as the model for its public hospital district plans. Peelyon had recently met with the local "life protecting agencies," including police, fire and social services, to ensure coordination between these related East County public safety entities.

Peelyon's efforts with the agencies were but a small aspect of how the community accepted and embraced the hospital. Nan Couts and the women's auxiliary served as a key asset for community integration. The auxiliary had already established

itself as the fundraising arm of the hospital. In October 1954, the auxiliary initiated its annual Harvest Ball fundraising gala. In 1955, the Harvest Ball helped fund the five-hundred-volunteer-strong organization, as well as supplies and equipment for doctors' lounge furnishings, books for the library and other needed items. The auxiliary also helped broker the many donations from East County businesses, service clubs and employee groups—such as the Kiwanis Club donation of a toy cart and the Convair Club's $12,500 donation for an X-ray unit. The "Pink Ladies," as the cherry-uniformed auxiliary volunteers were dubbed, also supported programs for juvenile patients like "Pinkie" the puppet. Pinkie helped entertain and comfort children scared with going to a hospital.

MODERN MARVELS

The hospital's significance was reflected in its modern design, scale and architectural style. By 1954, the Pereira and Luckman design was already getting rave reviews and awards. The modern design was evident to those in the architectural world. Featured in an article in *Architectural Forum* magazine in August 1954, it was billed as the "Expansible hospital." The building featured two different structural framing systems: cantilevered concrete for the long, narrow nursing wings and steel frame for the medical care facilities. The cantilevered concrete core allowed for elimination of columns that would have blocked views and increased costs. This also provided wider rooms, ensuring that both patient beds had window views. The steel truss frame medical care wing allowed for column-free, flexible spaces that could be rearranged with the changing needs of medical equipment and treatment demands. Nonbearing metal lath and plaster walls could be easily moved or removed as future operation remodels required. This compact, flexible space allowed for consolidation of utility systems and efficient clinical, diagnostic, supply, surgical, obstetric and emergency service department functions. This flexibility made for a design that had not only reduced construction costs but also enhanced the efficiency of the delivery of medical services.

Pereira and Luckman's hospital site and floor plan provided for potential lateral expansion in three directions off the main core. Expansion, a given prospect that the architects recognized, would definitely come with the imminent population growth of the region seemingly insured. However, not knowing what new medical specialties would be needed in the future

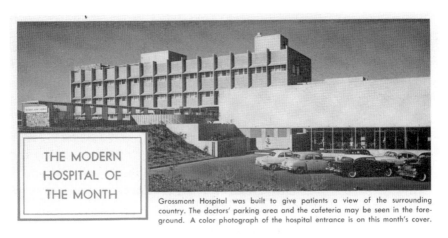

THE MODERN HOSPITAL OF THE MONTH

Grossmont Hospital was built to give patients a view of the surrounding country. The doctors' parking area and the cafeteria may be seen in the foreground. A color photograph of the hospital entrance is on this month's cover.

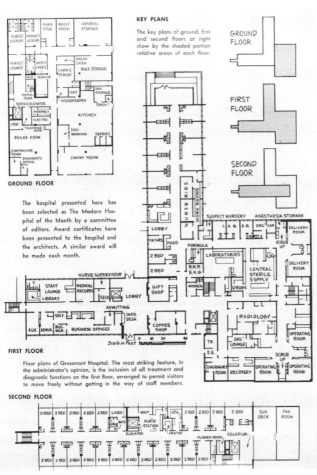

Above: Grossmont Hospital: Modern Hospital of the Month, 1957. *GH Collection.*

Left: Grossmont Hospital floor plan, 1957. *GH Collection.*

with the rapid advances in medicine and the particulars of the community's healthcare needs, the flexibility of the space would prove an invaluable asset.

Grossmont Hospital's original styling also reflected the modern symbolism of cutting-edge, future-focused thinking. Hospital planners believed the design would accommodate the promises that modern medicine represented to the community. From a stylistic perspective, the modern design of the core concrete structure with its large multistory glazed façades with delineated fins and horizontal sunshades was unmistakable. The Box Canyon (La Cresta) stone-faced stair block at the west end provided a local material element to break up the austere modern structure. Additionally, the steel-framed medical wing with its glazed walls provided not only additional natural light and easy adaptation of space but also a composition reflective of the latest in architecture and engineering.

Incidentally, Grossmont did not have to wait too long for its hospital and doctors to provide a modern medical marvel. An unexpected, rare and advanced medical procedure garnered national attention and identified Grossmont as an institution capable of such modern marvels.

Six weeks prior to its first anniversary, on July 2, 1956, the busy maternity ward saw the arrival of twins Gary and Lary Hutchens, sons of Mr. and Mrs. Floyd Hutchens of El Cajon. The hospital had already delivered several twins in its first year. However, Gary and Lary Hutchins were born physically attached—commonly called "Siamese twins," after a famous nineteenth-century set of twins from Asia. Conjoined twins are extremely rare, and the two brothers were San Diego County's first recorded case. Luckily for Gary and Lary, the main physical connection was tissue in the lower back area near the spine. Attending physician Dr. Leroy McDowell safely delivered the twin boys, but within days, the hospital had the media and medical attention of the nation.

Shortly after the boys' delivery, specialists arrived from Mercy and County Hospitals to assist the Grossmont doctors in the diagnosis and treatment. The team of surgeons determined that separation was feasible and planned the surgery for July 19—after the undersized twins had stabilized. Chief of Staff Dr. Soldmann oversaw the temporary press room established in the doctors' lounge to address the large press core covering the separation surgery. Dr. Thomas O'Connell of San Diego oversaw the team of eight doctors and four nurses during the surgery. The medical interest in the case resulted in a crew from Los Angeles filming the procedure. According to the American Medical Association, the Hutchens twins were only the fifth successful case of surgically separated conjoined twins at that time. Doctor

Dr. Thomas O'Connell and team preparing the Hutchens twins for separation surgery, July 19, 1956. *GH Collection*.

O'Connell and his team of Drs. Paul Pickering, William Berson, Marshall Persky, Leroy McDowell, James Higgins, J. Haddon Peck and Robert Baker received national exposure for the highly technical surgery.

Headlines of the successful surgery held at Grossmont Hospital graced newspapers across the country, from Seattle to Cleveland. On July 26, one week after the surgery, the Hutchenses took their twin boys home. Later, feature articles in *Time* and *Look* magazines as well as several medical journals reported on the story at the national level, bringing attention and acclaim to Drs. McDowell and Marshall Persky as well as Dr. O'Connell and the specialist team. The Hutchenses even went to New York to appear on television (quite the unique experience in 1956). In the end, local papers from the *San Diego Union* to the *La Mesa Scout* simply identified Gary and Lary as "medical marvels."

COLLEGIAL "COUNTRY" HOSPITAL

The Grossmont medical staff's team effort in the Hutchens case was typical of the working conditions in these early years. Years later, many of the physicians who worked at Grossmont in the 1950s recalled fond memories of the cooperative and respectful conditions of practicing there.

In a series of oral histories with many former Grossmont physicians sponsored by the San Diego County Medical Association in 2011–12, all remarked on the civility and collegiality of the doctors and staff. Since most of the early doctors were general practitioners, the convention of calling in specialists from the established Mercy and County Hospitals was considered common and acceptable until Grossmont could attract its own specialists. The memories of original staff doctors such as Ernest Shaw, Glenn Kellogg, Simon Brumbaugh and Henry Maguire, as well as others who arrived in the first few years, all remembered the great staff-building asset that the Grossmont Hospital doctors' lounge provided. It served as a meeting place for the physicians to obtain advice and consult with their colleagues. Many singled out Dr. Soldmann and the initial staff physicians for setting the tone that has continued for many decades. Dr. Henry Maguire recalled one of the most impressive and unique aspects of the Grossmont staff being how well the growing number of specialists were integrated smoothly into the operation.

Aerial image showing new Jackson Drive U.S. 80 Interchange and rural undeveloped nature of Grossmont Hospital in the 1950s. *San Diego History Center, Photographic Collection.*

A memorable aspect that the physicians all clearly recalled was the rural, undeveloped nature of the new hospital's location. As noted, the original access road to the hospital was extended from Wakarusa Drive to the east. Therefore, to the doctors of the 1950s, the hospital appeared to be located in the country. As such, one of the most consistent memories was of the large jackrabbit population. The original landscape of the hospital included a lawn adjacent to the parking area. Memories of driving up the "dirt" access road and seeing dozens of rabbits over the grounds attracted to the green, irrigated grass resonated with all the early physicians—and their children. In late 1956, the hospital did establish a more direct entrance to the west across the future Grossmont Center property down to the newly extended Jackson Drive. This coincided with the Department of Highways completion of the Jackson/U.S. 80 highway interchange that year, creating a more direct access to the "country hospital on the hill."

The result of the Grossmont medical staff's good working relationships was good medicine. Hospital archives feature annual scrapbooks of these years. In the first few years, the scrapbooks are filled with dozens of articles on the treatments and accomplishments of the hospital and its staff of doctors and nurses. The coverage, mostly in the local East County newspapers such as the *La Mesa Scout*, *El Cajon Valley News* and others, reflected on the community's acceptance, appreciation and recognized value of these dedicated, community-focused medical professionals.

Delivering a Rapid Expansion

As Grossmont Hospital entered its second year, the concept of resting on its medical laurels was far from anyone's mind. In late July 1956, the board took Louis Peelyon's suggestion and requested preliminary plans from Pereira and Luckman for construction of a new seventy-eight-bed wing addition. Peelyon had reported in the local papers in August 1956 that the hospital was running at nearly 90 percent of the facility's capacity. East County's demand for service continued to increase with its rapid growing population, especially in El Cajon and La Mesa. By January 1957, local newspapers were reporting that the overcrowding was such that the hospital was setting up beds in hallways and restricting admissions.

In November 1956, administrators of the eight largest county hospitals, including Grossmont and the new Sharp Memorial of San Diego, which

opened two months prior, met to discuss the challenge of keeping up with the healthcare demand. The hospital professionals heard that the perceived need for eight hundred new beds in the coming years could grow to as many nine hundred or one thousand additional beds due to the expanding county population.

Such concerns—along with an already overcrowded hospital—led the Grossmont Board of Directors to call for a $2 million, 143-bed expansion in March 1957. The board felt confident in its ability to double the size of the hospital, even though it had been in operation for less than two years. The hospital's maintenance and operations fund had grown to $465,000. In April, the board authorized a special election for June 1957 to authorize expenditure of those funds and $134,000 in remaining 1953 bond funds toward the expansion. The district had already made a request for $1.2 million in additional state-granted Hill-Burton funds. With overcrowded conditions and a solid fiscal track record, the district expected to receive the grant funds in July 1957.

The previous success of the under-budget and ahead-of-schedule construction of the initial hospital helped convince the community to support the new proposal. Once again, community and civic leaders aligned to support the expansion. William Pereira returned to add support to the expansion cause, noting that the original design was planned for expansion and that construction should once again be under the national average hospital cost. On June 11, 1957, the voters supported the ballot measure. It passed, again by an 8 to 1 margin as in 1953.

Unfortunately, the expected Hill-Burton Act funds were not granted in July 1957. The district was forced to delay expansion plans and reapply in September 1957 for funding in 1958. In March 1958, the board would reengage Pereira and Luckman to move forward on finishing the expansion plans. The state board came through with a $1,334,502 grant in August 1958. Peelyon and his staff quickly moved to bid the project and awarded it in December at a cost of $1,699,000. On January 12, 1959, Director Forace Boyd turned the first ceremonial shovel of soil.

The new four-story South Wing would take eighteen months to build. Its opening would coincide with the fifth anniversary celebration in August 1960. The hospital's additional 134-bed wing raised its capacity to 245 beds. At the August 15, 1960 dedication, the board invited original director Burton Jones to return as master of ceremonies—just as he had in 1955. John Derry, assistant chief of the State Bureau of Hospitals, accepted the hospital on behalf of the State of California. Reverend Charles Hamby

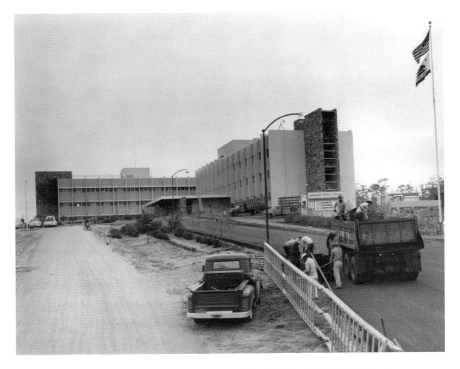

Above: Paving new entrance road adjacent to new South Wing, 1959. *GH Collection.*

Below: Invitation to Grossmont Hospital's fifth anniversary and new addition dedication, August 15, 1960. *GH Collection.*

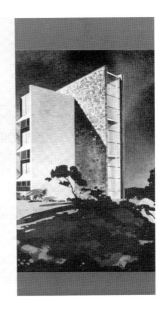

The Board of Directors and Staff

of

GROSSMONT HOSPITAL

Cordially Invites You to Attend

the

Fifth Birthday Anniversary

and

Dedication of the New Additions

10:30 A.M.
Monday, August 15
Grossmont Hospital

of First Presbyterian Church of El Cajon, Father George Lambert of St. Martin's of La Mesa and Rabbi Monroe Levens of Tifereth Israel Temple provided benediction and blessings. Over two thousand attended the event. Reflecting on the dedication of the Grossmont staff to the young hospital, thirty-three employees received five-year service pins, with thirty-four more receiving three-year pins.

Articles reporting on the event chronicled not only the doubling of the physical plant but also the numerous improvements in programs and equipment that had occurred in the first five years. Grossmont received its initial accreditation, something most hospitals worked many years for, in February 1957. Several months later, it was featured in *Modern Hospital Magazine* for its excellence in architectural design, functional plan and economic cost of construction and operation. This honor correlated with the State Department of Public Health's 1957 Modern Hospital of the Year Planning Award.

In March 1958, Grossmont opened its radioactive isotope lab (the first in the county), later adding a state-of-the-art hydrotherapy facility. By 1960, it had enhanced its clinical lab with an automatic tissue-processing machine, installed a hospital-wide air sterilization and conditioning system and constantly kept up with the latest in X-ray and other neurological machines

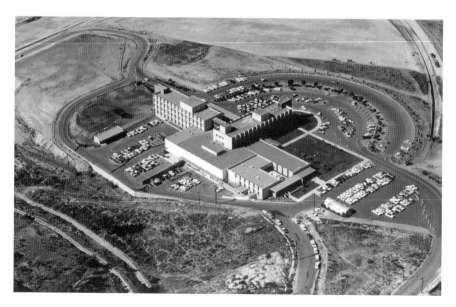

Grossmont Hospital aerial photo, view northwest, 1960. *GH Collection.*

among other high-tech equipment of the day. Additional cutting-edge operational improvements found at the hospital during this period included new "cigarette-sized" radio transmitters to contact doctors—later known as pagers—acceptance of multiple insurance plans and "courtesy admit cards" to allow billing after treatment for district residents.

In its early years, Grossmont Hospital had quickly become the major healthcare institution for the region. But with the growing demand for healthcare, it was not alone. The La Mesa Community Hospital was still in operation, renamed Helix Community Hospital. A private physician-owned facility, the Lake Murray Community Hospital in west La Mesa, had also opened along with the College Park Hospital in the College Area. In 1960, local doctors Lowell Smith, William Herrick, Cody Smith and Al Woodall, all of whom had practiced at Grossmont, opened the sixty-four-bed El Cajon Valley Hospital adjacent to U.S. 80 at Greenfield Drive. However, near the same time of El Cajon Valley's opening, the growing challenges of making hospital care a profitable venture had driven Lake Murray to bankruptcy and put Helix in receivership.

Growing Pains

Of course, not all aspects of Grossmont's operations ran smoothly. The administrative challenges of meeting all the staffing and equipment costs hung over both the board and administrators. Each year, the board of directors faced the question of raising fees or assessment rates to keep up with the growing costs of operations and equipment. Each year, the board wrestled with raising rates while attempting to avoid passing on the constant cost increases to district residents. Yet each year the hospital's growing business was able to make a profit.

Staffing costs became one of the most hotly discussed board issues in these early years. In early 1959, the board approved a fifteen-dollar-per-month salary increase for nurses amid great debate. Later that year, joining into the growing national trend, it required employees to have health and accident insurance. With a 50/50 contribution plan, the board made participation mandatory to justify the cost, considering that only 5 percent of the employees had originally joined.

The early hospital physicians also discussed their own compensation challenges during this pre-Medicare era. Other than employees of larger

Grossmont Hospital administrative staff portrait, 1960. *GH Collection.*

companies such as Convair and Rohr aircraft, few patients had health insurance at this time. The doctors from this period all commented later during their oral histories in 2011–12 on the challenges of getting payment from many of their patients. Oftentimes receiving no compensation, such pro bono work for those who could not afford to pay became an accepted part of the business side of medicine. Several recalled that the early emergency room was staffed first by volunteer physicians a few days a month per a rotating schedule. Although this was often a good way for young doctors to obtain new patients, efficient and dedicated emergency services would become a challenge for future administrators.

Although some of these issues caused concern and angst at times between staff and management, the hospital governance had stayed relatively stable. In September 1956, Director Herbert Burrell resigned to take a hospital job outside the county. Almost immediately, the board reappointed Homer

Streich to fill the opening. In the meantime, only Jack Atkinson had joined the long-standing board of Marvin Jackson, Ralph Peterson, Forace Boyd and Homer Streich.

In late 1960, the first sign of coming changes occurred when Marvin Jackson decided not to seek a third term as president. In early 1961, Jackson, president since the formation of the district in 1952, handed the presidency to Forace Boyd. Although Ralph Peterson would also resign in December 1961, the biggest change occurred when Louis Peelyon, in many ways the institution's practical and efficient visionary leader, announced his departure in late 1961.

ENTERING THE SPACE RACE

THE HILLTOP LANDMARK

In just a few short years, Grossmont Hospital had become an entrenched community landmark and model medical institution. In many ways, Grossmont aligned itself with the idealized vision of a modern, technologically advanced medical facility that operated within a stable financial business model. In Grossmont Hospital District's particular case, the stability was its public agency status. As noted, the challenges of consistent reimbursement and steadily rising costs of medical care had already placed several smaller hospitals, such as Lake Murray Community and Helix (former La Mesa Community), into financial straights.

Grossmont, of course, was not immune to the recognized challenges facing hospitals and healthcare providers in the 1960s, such as spiraling costs, bed shortages for a rapidly growing population, poor coordination of agencies, competition for paying patients between hospitals and adjustment to coming government reimbursement bureaucracy. In San Diego County, these issues were also compounded by haphazard regional planning to coordinate expansion. Some critics cited such issues as significant contributors to the failures of various institutions that had either built beyond their ability to capitalize their necessary growth or were not able to provide or be reimbursed for the actual services delivered or demanded of their constituents.

Grossmont Hospital in the 1960s was in many ways both typical in its addressing the challenges American hospitals faced as well as unique in continuing to sustain its fiscal stability while joining the race to ensure

*Y*our **GROSSMONT HOSPITAL**

*D*edicated in 1955, Grossmont Hospital stands as a tribute to
the vision, determination and generosity of the people in
the district which it serves . . . Designed and created
to provide modern, efficient medical care and treatment to help
insure the health and welfare of thousands of patients each
year, Grossmont Hospital has far exceeded the high goals for
which it was established . . . To continue measuring its
progress in terms of successful growth, your constant understanding
and support are required . . . Know your hospital, acquaint
yourself with its duties and responsibilities, its services
and facilities, its growth and achievements . . .
Your hospital is an integral, vital part of your community.

GROSSMONT HOSPITAL DISTRICT

SERVING THE CALIFORNIA COMMUNITIES OF Alpine, Bostonia, Campo, Descanso, Dulzura, El Cajon, Fletcher
Hills, Grossmont, Jamul, Lakeside, La Mesa, Lemon Grove, Pine Valley, Potrero, Santee, Spring Valley

Left: "Your Grossmont
Hospital," fifth anniversary
booklet, 1960. *GH Collection*.

Below: Grossmont Hospital with
"La Suvida" neighborhood in
background, 1960. *GH Collection*.

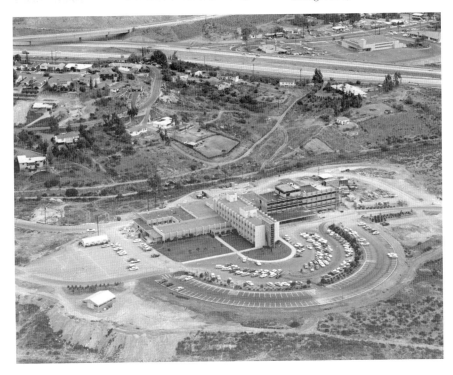

it kept up with public, medical and patient expectations. In general, the board and administration continued to find a budgetary balance amid a constantly growing staff and the changes in modern medicine, including new specialties and subsequent technological advances and requirements.

The overarching issue for the hospital as it entered the 1960s was meeting the space needed for continuing growth and expansion. In February 1961, President Jackson and Administrator Peelyon issued statements published in the *El Cajon Valley News* that solidified the foundation for the hospital's direction over the next decade. Jackson commented on the perceived situation of the recently doubled in size hospital seeing another projected doubling of the district's population. The long-standing board president boasted, with concern, that the hospital had admitted over fifty thousand patients and delivered ten thousand babies in just six years. He noted that in less than another five years, the hospital board was afraid it would be facing a critical bed shortage again. Jackson mentioned that he hoped the Grossmont District would be able to use its bonding and taxation powers as a public entity to avoid reliance on outside state or federal funding.

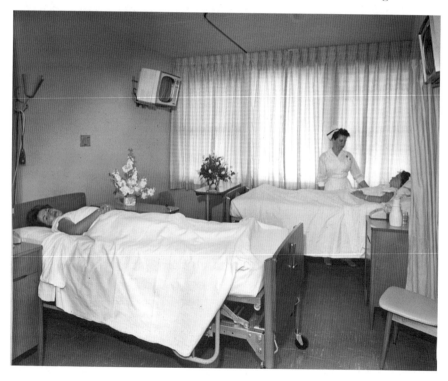

Patient room, Grossmont Hospital, 1960. *GH Collection.*

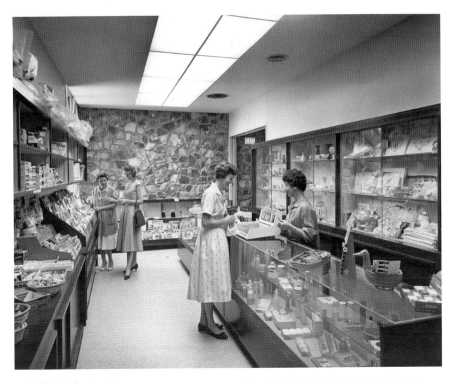

Grossmont Hospital's gift shop, operated by the women's auxiliary, 1960. *GH Collection.*

Peelyon responded to the board's concerns in the hope that new administrative and treatment approaches could help quell the perceived inherent need for more and more hospital space. He described the concept of progressive patient care, in which patients were moved through reduced treatment stages from intensive care units to reduced nursing care units, then minimal nursing convalescent units and finally outpatient treatment in patients' homes as a potential answer to controlling treatment and expansion costs. Peelyon's comments were precursors to the coming concepts of highest need usage, instead of continuing to pursue the hospital space race.

THE CHANGED LANDSCAPE

In October 1961 the remote and quiet landscape surrounding Grossmont Hospital changed dramatically. Grossmont Center, the third regional

shopping mall in San Diego County, opened. The new 110-acre shopping mall represented the latest in modern retail center design and a $20 million investment for the City of La Mesa. The mall site was the remainder of the Adolph Levi lands from which the hospital district had purchased its property. Levi's daughter Sarah Levi Moore had placed the mall property into a trust for her teenage grandsons Stephen and Lawrence Cushman—still owners of the property today.

In September 1957, Elliot Cushman and Hamilton Marston, head of San Diego's Marston's Department Store, announced plans to construct what was planned as the largest regional mall in the county. The family hired the nationally known Del E. Webb Construction Company as developers and the Los Angeles planning and design firm of Welton Beckett and Associates as designers.

The City of La Mesa negotiated with the developers over the city's improvements to Jackson Drive as well as the relocation of the hospital's access road to Jackson Drive as part of the agreement to annex the property

Grossmont Center under construction, May 9, 1960. *La Mesa Historical Society Archives.*

to La Mesa. The city annexed the site in December 1959, and center construction began in May 1960. One of the contractors' most challenging tasks was the removal of some 1.4 million cubic yards of material to grade and fill the one-hundred-acre development site. The $10 million mall construction project required over 1,200 tons of steel and 25,000 cubic yards of concrete and quickly shifted Grossmont Hospital from a remote and inaccessible location into the busiest and most active city neighborhood.

Grossmont Center's opening in October 1961 also signaled the opening of the surrounding north La Mesa neighborhoods as well as the remainder of Fletcher Hills to the northeast. With the opening of Fletcher Parkway in 1955, the area developed quickly as did the San Diego City neighborhood of San Carlos, opened in 1959. The Briar Tract area just east of the hospital site, the location of the original San Diego Flume Company's Eucalyptus Reservoir, was soon redeveloped as a city recreation area (later Briarcrest Park). In meeting demands from these growing suburban neighborhoods, the La Mesa Spring Valley School District opened the Briar Patch Elementary School across the street in 1958.

Not all the changes to the surrounding area were additive, however. The small La Suvida community of homes located on the knolls directly to the east of the hospital but west of Eucalyptus Reservoir would soon be the casualty of the expanding U.S. 80 freeway and future plans to extend the Bancroft Freeway (which had opened in 1957 from State Route 94 in Spring Valley to U.S. 80) north past the rear of the hospital and onto Santee (later State Route 125). The State Department of Transportation eventually purchased and demolished the neighborhood's two dozen homes for the future freeways.

CHANGING LEADERSHIP

In early 1962, the hospital greeted a new and changed landscape and new leadership. Louis Peelyon, who had been intimately involved in the planning, construction and operation of the hospital for nearly a decade, had decided to move on to a new challenge in the building and opening of the new Scripps Hospital in La Jolla. As an editorial in the *El Cajon Valley News* clearly stated, Peelyon's departure left a "gaping hole in the administration of this important public institution." The board reacted quickly to his November 1961 resignation with the hiring of Leverett Bristol as the new administrator.

The hospital's employees' association and women's auxiliary held a special tea in December to honor Mr. Peelyon and his wife, Alice, as well as welcome Mr. Bristol and his wife, Virginia.

Leverett Bristol's credentials in hospital administration were strong. The North Dakota native and University of North Carolina graduate had worked as a CPA before coming to California, where he worked at Ryan Aeronautics in San Diego. He then moved to Riverside County, where he opened one of the earliest Hill Burton–funded hospitals, Hemet Valley. Bristol then moved to Exeter in Tulare County and opened Memorial Hospital. In 1954, he took over at Coronado Hospital, where he and his family lived. Bristol was a member of numerous professional hospital organizations and served as president of the San Diego County Hospital Council.

Bristol's administration coincided with that of the new board president, Forace Boyd. Boyd had taken over in 1961 for Marvin Jackson, the only board president the district had known. Additionally, in December 1961, board member Ralph Peterson had resigned to take over as manager of the new Montgomery Ward department store at Grossmont Center. In February 1962, the board appointed James Spears, Lemon Grove automobile dealer, to fill Peterson's vacated spot. The board chose Spears from several candidates from Lemon Grove to ensure representation from throughout the district. When Spears passed away unexpectedly in 1963, the board named retired U.S. Navy officer B. Charles Hesser of Lemon Grove to fill his spot.

In the 1960s, the board would be presented with increasingly more difficult issues. The district's successes led to proposals to expand the scope of its operations. In the early years, the board and administration were approached about taking on mental health facilities and nursing homes. The board fended off these ideas in order to continue to address the challenges of keeping the hospital operations solvent. In 1962, the board was approached about acquiring the bankrupt Lake Murray Community Hospital in La Mesa, which it resisted. Four years later, the board received a San Diego County Health Facilities Planning Commission proposal to merge maternity services with local Heartland and El Cajon Valley Hospitals. None of the three hospital administrators felt comfortable with the idea, and as Leverett Bristol noted, such a merger would require a public vote of the Grossmont District. The commission later shelved the concept.

The board showed far more concern toward the efforts of the local building services union of the AFL-CIO to organize the hospital's employees. In 1962, the directors sought input from the district's legal council on their options and obligations. Director Jackson was quoted

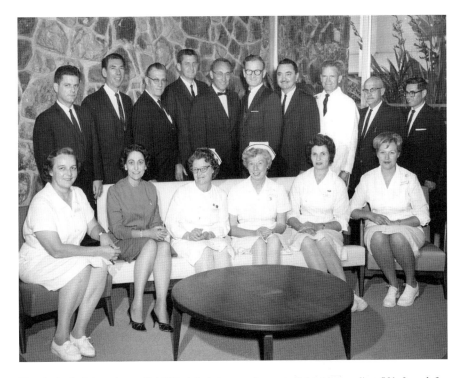

Hospital administrative staff, 1964. Administrator Leverett Bristol is standing fifth from left. *GH Collection*.

in the *El Cajon Valley News* on his hope that the relationship would stay "nice, clean and on a firm precise basis." In 1966, hospital negotiations with employees led to additional pension benefits and a 5 percent salary increase. Such cost increases added challenges to the already rising costs of equipment, supplies and growing staff.

Board politics also became a more pronounced concern. The 1964 board election saw ten candidates vying for the seats of incumbents Forace Boyd, Jack Atkinson and Marvin Jackson, including the first two female candidates, dietician Mary Kingsbury and writer/hospital critic Margaret Juerdon. Boyd, Atkinson and Jackson won reelection, but not without significant campaign efforts.

Former original board president Marvin Jackson resigned from the board in April 1965, leading to the appointment of La Mesa automobile dealer Hazen Streit Sr. Streit was named president the following year. The board turnover continued late in the decade. Dr. William Soldmann, original hospital chief of staff, was appointed to the board in 1967 to replace C.B.

Hesser, then elected to a full term in November 1968. Soldmann would be one of the longest-serving directors. In 1968, George Hurst joined the board, replacing Hazen Streit. Hurst would become another long-serving director.

Original board member Homer Streich had been one of the most consistent and supportive directors. Streich was beloved among the administration and volunteers; the auxiliary's Annual Award for Longest Continuous Service is named for him. He passed away unexpectedly in early 1969. In his honor, the hospital's "quiet room" was named for him as well. As long-serving editor Evelyn Foreman wrote in the June 1969 *Grossmont Hospital Capsule*, "[H]is passing left a void."

San Diego Gas & Electric Company manager Kenneth Brown would be appointed to fill Streich's vacancy. Brown was a former navy man and a long-term leader in local civic and service clubs in El Cajon. Director Jack Atkinson would also resign in 1969. Atkinson's replacement was Santee resident Proctor Newhan. Newhan was an engineer with Pacific Telephone and had served on the Otay Municipal Water District Board, among many other service organizations.

In addition to changes to the board, some long-serving administrative staff also began to change. In 1966, original controller Claude Dooley Jr. left to take over as administrator of the El Cajon Valley Hospital. During that same time, other original employees, such as nursery and recovery room managers Marie Merchant, RN, and Claire Richey, both retired. The next year, Everett L. Jones, construction manager with Louis Peelyon and long-serving clerk of the works, and Louisella Klaesson, original admitting clerk, also retired. As reported in the *Capsule* of March 1967, only 18 original members were left of the 157 opening day staff among the now over 600 hospital employees.

TAKING PAUSE, THEN KEEPING PACE

On Sunday August 15, 1965, the district celebrated the hospital's tenth anniversary. All twenty-two original remaining employees were given ruby service pins for ten years' service. Thirty-six employees received gold five-year service pins and another forty-eight silver three-year pins. The program also featured a brief look back at the successes of the first decade. Administrator Leverett Bristol reported on the accomplishments of the staff and volunteers, including the now ten-year-old Grossmont Hospital Employees' Association,

Grossmont Hospital

CAPSULE

August 15, 1965 • Grossmont Hospital, La Mesa, California • Volume VIII, No. 8

CEREMONIES SALUTE TENTH ANNIVERSARY

Original Employes Given Gold, Ruby Service Pins

Each year the ranks of 155 original employes who were in attendance the first day Grossmont Hospital opened its doors grow fewer.

With resignation of two veterans, Hugh McDaid and Grace Stacy, during the past year, twenty one original staff members will receive the gold pin set with a ruby. In 1963 three board members received these pins, and in 1964 EVERETT L. JONES received one, the first employes to be so awarded. Pictures of the ten year veterans are on pages 6 and 7.

Five Year Pins Given For Service

Marking their staff membership by receiving the gold service pin which denotes five years of service, are the employes listed on the yellow program insert sheets.

Group Receives Three Year Pins

Receiving their first service pin award is a group of three year employes. They are listed in the yellow program.

Representing a decade of history of Grossmont Hospital, Leverett F. Bristol, left, and L. M. Peelyon, right, present and former administrators, are shown sometime ago as they discussed a matter with F. L. Boyd, president of the Board of Hospital Directors. Opening August 15, 1955 with Peelyon as administrator, the new 111 bed hospital filled a desperate need of 89,000 persons with but one 34 bed hospital in the newly formed district.

"Today," said Bristol, "this 234 bed hospital is a vital part of the lives of 200,000 persons residing in the district of 730 square miles." (More, Page 2)

PROGRAM OF THE DAY—YELLOW INSERT

Tenth Anniversary Ceremony Issue, *Grossmont Hospital Capsule*, August 8, 1965. *GH Collection.*

its six-year old GHEA Credit Union and the important and essential work of the hospital auxiliary volunteers. Reflective of the impressive service the hospital had provided in the first decade were these figures: 106,700 admitted patients with 20,823 babies delivered; patient-days of service amounting to 482,460; medical staff undertaking 62,820 surgical procedures and treating 64,628 emergency patients.

Board president Forace Boyd then spoke on the hospital's future. Boyd emphasized that the greatest challenges for American hospitals were about to be enacted with the impending federal Medicare program. Boyd reflected the concerns of hospital administrators and physicians nationwide on the potential effects of the new program increasing the patient numbers at the already at-capacity Grossmont. He asked for greater understanding and cooperation between the medical and administrative staffs to deal with the coming changes. Boyd concluded with an exhortation that the board be vigilant in planning the hospital's growth to address continuing district population growth and the expected influx of new Medicare patients.

In conclusion, Boyd emphasized the current effort to meet the existing and coming demands with a new $6 million expansion of the hospital. In fact, the board and administration had started their planning efforts in February 1964 by hiring Hospital Planning Associates of Malibu to complete a new hospital master plan. The consultant's master plan concluded that Grossmont Hospital needed to expand its physical plant to meet district health needs but also showed potential to become a research and exploratory institution. Armed with the new master plan, in August 1964 the hospital put out a request for qualifications for an architect to assist with plans for the first phase of the planned expansion. This expansion hoped to add 120,000 square feet and 120 new beds to the hospital.

In January 1965, the hospital hired San Diego architect Richard Wheeler and Associates. San Diego native and son of early prominent local architect William Henry Wheeler, Richard had created one of the largest architectural firms in the county. He and his firm had designed hundreds of commercial and residential projects as well as the recently completed Grossmont Junior College and then under construction Paradise Valley Hospital. A Modernist in style and design, Wheeler had also had a short professional affiliation with original hospital designer Charles Luckman in the late 1950s.

Wheeler worked with administrative and medical staff and consultants on the major addition's design. After a year of meetings and design review, Wheeler and Bristol unveiled the $4 million expansion program. Although

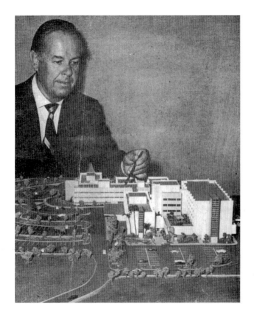

Architect Richard George Wheeler with
Grossmont Hospital expansion model,
1967. *GH Collection.*

hospital critics found the $4 million price tag high, it represented a reduction
from an original $7 million concept. The reduced expansion proposal still
included a five-story tower addition to the hospital, a new power plant,
an administrative building and a possible helicopter landing area to help
serve the emergency services unit. The new addition planned to add space
to the overcrowded medical, surgical, orthopedic and emergency services
departments. Bristol and the board emphasized the growing number of
patients being turned away for lack of space.

In the meantime, the hospital had already authorized expenditure of
$1 million on a new power plant that would go into construction in the
summer of 1966. Improvements to the new intensive care unit, including
new electronic monitoring equipment, were completed later that year as
part of emergency services unit upgrades.

All the proposed spending, along with concerns of the uncertain long-
term effects of Medicare on the already taxed hospital's services, only
exacerbated the already concerned taxpayers' organizations and hospital
district critics. They had been fueled when the board approved its first
ever deficit budget for fiscal year 1966–67. The critics considered the
budgeted $108,280 deficit "staggering." Although Bristol and the board
understood that the risk was not great, it fueled criticism of the district
leadership. Wheeler completed plans in 1966 for the new administration
building, including space for the auxiliary and its volunteers. When the

construction bids came in over estimate in late 1966, the board held up authorizing the expenditure.

After things settled down in early 1967, as well as a grant from the auxiliary to cover landscaping costs, the board authorized the construction for a new administration building and landscaped parking area. Construction started in April on the building to be located just west of the maternity wing, north of the main building. It was to house an auditorium for 225 people, a new doctors' lounge, a conference room and medical records archive space with the upstairs housing the new administration offices. It was scheduled to open in the fall of 1967, after the new power plant came online in late summer. Administrator Bristol noted that the completion of these "smaller" projects was as essential as the hoped-for tower addition.

Funding of the proposed $8 million tower addition required district voters to approve a new bond issue for the proposed three-hundred-bed wing. As they had previously, the district and auxiliary oversaw the campaign. Homer Streich once again led the campaign for the latest

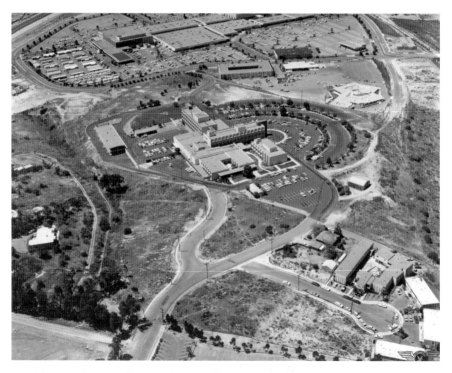

Grossmont Hospital, aerial view west, 1969. *GH Collection.*

expansion proposal. The November 29, 1967 special election proved far different than previous district efforts. District residents did not seem as motivated or interested. Less than 14 percent of the district's registered voters cast ballots, and although the issue received a majority vote, it did not receive the necessary two-thirds approval required for bond issues. The district tried again in 1968 but fell short of the required votes.

These first major setbacks to district leadership's plans only delayed addressing the growing needs of the hospital in keeping up with the medical needs of the community and medical staff. Over the next several years, regular reports of turning away non-emergency patients and scheduling delays for elective surgeries were typical of the continuously overcrowded hospital. Part of the overcrowding was from the growing staff, which rose from 650 in 1966 to over 800 by 1970.

KEEPING UP WITH MEDICAL TECHNOLOGY

A major challenge for the district board and administration during this period was providing the highly trained and talented doctors with the latest in tools and equipment with which to practice. Bristol and the administration had a reportedly good working relationship with the medical chiefs of staff during the 1960s in their cooperative efforts to provide necessary equipment and facilities. Several of the retired doctors recalled in their 2011–12 oral histories the pride of Grossmont Hospital being the site of the county's first radioisotope scanner and laboratory.

Precursor to today's high-tech diagnostic techniques and scanners, this type of expensive and cutting-edge technology was essential for the existing staff but helped Grossmont Hospital recruit new specialists who helped diversify the Grossmont medical staff. Other new systems, such as the "Medicall" telephone pager, electronic monitoring for intensive and emergency room care and aforementioned medical library and doctors' lounge, allowed the staff to keep up with the latest techniques and treatments. Surgeon Daniel Smith recalled a rare case of latent hypothermia that his surgical assistant Dr. Al Agudelo had been reading up on just prior to a case that Agudelo diagnosed on the surgery table, saving the patient. Such stories were widespread, and as former radiologist Dr. William Pogue recalled, and most of his colleagues concurred, doctors of his generation generally studied harder after medical school graduation to keep up with the constant changes in medicine.

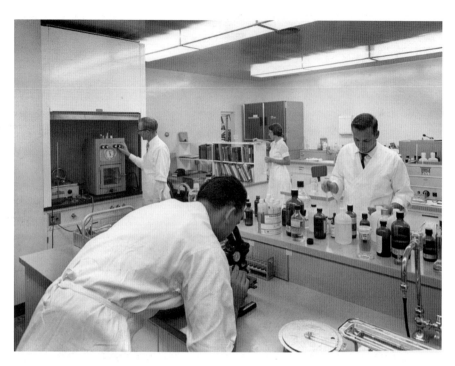

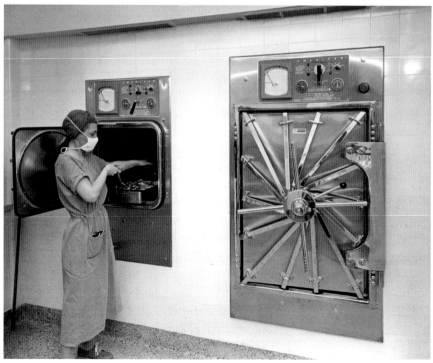

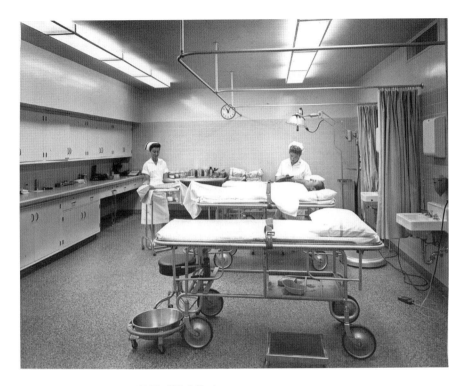

Above: Emergency room, 1960. *GH Collection*.

Opposite, top: Clinical laboratory, 1960. *GH Collection*.

Opposite, bottom: Operating room central supply, 1960. *GH Collection*.

As such, the hospital scrapbooks from this period recount the additional training and educational programs that the physicians and nursing staff took advantage of during these rapidly advancing times for medicine. One new local opportunity included the establishment of the UC San Diego School of Medicine (UCSD) in 1962. Its agreement to operate the newly constructed San Diego County Hospital in 1966 provided the other county hospitals university training, internship programs and continuing education. This was especially beneficial, as doctors from the 1950s like Dr. Henry Maguire recalled having to send doctors to UCLA or USC in Los Angeles to attend similar symposiums or trainings prior to UCSD.

Such benefits were required of the constantly growing and diversifying medical staff of both general practice and specialist physicians. By July 1968, for example, the medical staff totaled 712 professional men and women, including 62 dentists. Staff membership at the time included 483 doctors on

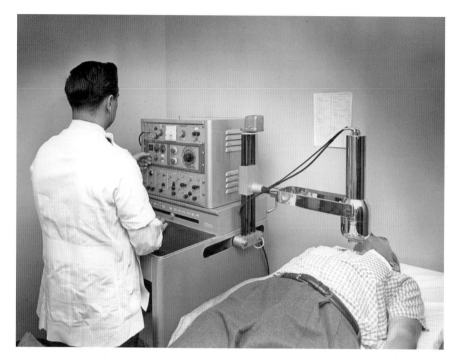

Radioisotope laboratory, 1960. *GH Collection.*

VOLUNTEERS

CANDY STRIPER YOUTH PROGRAM

High school girls, in their sophomore year, volunteer their services in many areas of the hospital. This program affords many students an opportunity to study hospital careers. They can be identified by the red- and white-striped pinafore. These girls act as messengers and perform duties under the direction of the supervisors of the administrative areas.

These girls serve year round. Many Candy Stripers receive scholarships to further health fields.

Volunteer candy stripers program, *Hospital Brochure*, 1970. *GH Collection.*

the courtesy staff, 136 on the active staff, 17 associates, 10 consulting and 4 honorary doctors.

That year, Dr. A.L. Edgar, taking over from Dr. Vernon F. Perrigo as chief of staff, oversaw several departments and committees aimed at supporting both the staff and, ultimately, the community. The department chairs included Dr. Robert Hindman (surgery), Dr. Henry Maguire (obstetrics and gynecology), Dr. C.R. Graham (general practice), Dr. A.J. Klein (internal medicine), Dr. G.M. Mahan (pediatrics) and Dr. G.F. Holland (dentistry). The staff committees included the building committee, assisting with design of the new addition; by-laws and rules; and emergency services, in charge of reviewing emergency room and intensive care units. Additional committees indicated the growth of the medical specialties, including isotope, lab and infection control; library; medical-dental liaison; patient care; perinatal mortality; pharmacy and therapeutics; physiotherapy; therapeutic abortion; tissue, transfusion and utilization; as well as licensed nurses.

The Grossmont Hospital Women's Auxiliary continued to provide support to both the staff and operations. In 1964, the auxiliary had an average of 118 "candy stripers" averaging fifty hours a year in volunteer support. Their value was illustrated in a January 1966 *San Diego Union* article detailing their key roles as aid to the staff and providers of patient comfort. In addition to the Annual Harvest Ball, still the number one auxiliary fundraising event, the ladies would add other events such as a home and garden tour in the early 1970s. They also assisted with unique programs, such as hospital tours for juvenile patients prior to surgery and a long-standing program to acquire medical release forms for the district's school-age children to ensure such records were on file in case of need for emergency treatments when parents were not readily contactable. (Remember this was some two decades before cellphones.) In addition, the auxiliary began its long-standing scholarship program for those young women and men who wished to pursue careers in medical professions.

COSTS, CRITICS AND CONTROVERSY

Grossmont District's board of directors had always required and obtained a balanced budget in the early years, doing its best to avoid raising fees significantly or using its power to assess higher tax rates on the district property owners. However, the board-approved budget in June 1964 for

fiscal year 1964–65 required an 11 percent increase in rates for rooms and services. Although Leverett Bristol documented that Grossmont's new daily room rate was still the lowest among comparisons with San Diego's Sharp Memorial, El Cajon Valley or Chula Vista Community, for the first time, vocal public critiques of the hospital arose. The *El Cajon Valley News* responded with an editorial questioning the fundamental challenge of paying for the latest in medical care, "Who Can Afford to Be Sick Today?" Other articles followed, questioning the cost of physicians in specialty departments such as pathology and radiology. In October, around the time of the first hotly contested board election the *Valley News*, another more directly aimed editorial appeared, titled "Is Soak-A-Patient a Fair Policy?"

Each year, such critiques on district and hospital expenditures garnered more attention among the press and public. When the board approved the second straight year of twenty-cent tax assessment increases for the district, the maximum the district was allowed to increase in any one year, the critics rose up again. The challenge of raising rates would continue annually along with the growing budgetary needs to match the demand for needed hospital services. Just five years later, in 1969, the board raised the daily rates from $7 to $60 a day. These rate increases were an effort to try to balance a now $8 million budget—double that of just five years previous.

Although the budget garnered attention annually, one of the most controversial episodes dates to 1966 as well. Staffing the emergency room and the growing acute care services triggered the first significant conflict between the administration and medical staff. The conflict was in response to an issue brought up in a January 1965 letter from previous board candidate and hospital critic Margaret Juerdon and reported in the *El Cajon Valley News*. Juerdon questioned the hospital policy of patients being required to alert their personal physician or the hospital prior to arriving at the emergency room. Board president Forace Boyd had requested assessment of the cost of always assigning a resident doctor to the emergency room. Chief of Staff Dr. Simon Brumbaugh reported back that the hospital's policy, as reexamined by the Doctor's Emergency Room Committee, saw the existing policy as consistent with the standard private physician-patient relationship with which most patients and physicians were comfortable. Brumbaugh also reported that many emergency room patients only needed first aid and that the on-call nurses provided that service while waiting for a patient's personal physician to arrive.

The doctor's position did not end the public's and board's concerns. In September 1966, the question of proper staffing of emergency services rose

up again after a patient awaiting treatment in the Grossmont emergency room died before his doctor arrived and any treatment was undertaken. Both sides of the issue were then detailed in a series of articles in the *El Cajon Daily Californian* newspaper. Not only did members of the public criticize the hospital policy, but it also broached the question of who was in charge of the hospital—the board and administrators or the doctors. Director Homer Streich was clearly critical of the physicians, citing their reluctance to staff the hospital round-the-clock as being the underlying issue. Directors Streich and B. Charles Hesser came out in support of establishing a policy that active physicians must undertake on-call shifts to ensure qualified medical staff attend the emergency room at all times. Streich noted that the current medical staff didn't want the hospital to hire dedicated emergency room physicians since the private physicians would be unable to bill their patients for treatments performed by hospital doctors.

Chief of Staff Dr. Russell Lowell and Administrator Leverett Bristol reported later that month that the staff was ready to offer up a compromise. Doctors would volunteer to cover shifts in the emergency room to ensure proper coverage. Other county hospitals noted that they paid emergency room doctors a small stipend per shift to ensure coverage. Dr. William Soldmann, similar to several of the other veteran doctors, thought the issue "was much ado about nothing." The emergency room issue was the focus of the hospital for several months that fall. In December, Dr. Lowell announced in the *Daily Californian* that sixty-two doctors had volunteered to take a shift a month to ensure around-the-clock physician presence in the Grossmont emergency room. Although this quelled the immediate concerns, later issues would affect the hospital's ability to provide a full-care trauma center.

THE ARRIVAL OF MEDICARE

As noted in the introductory chapter, the passage of Medicare had a profound effect on American hospitals and healthcare providers. The general public's optimistic hopes that this federal program would slow the rise of or reduce hospital and healthcare costs proved illusive. Congress's passing of the Medicare and Medicaid legislation in 1965 did provide hope to many who had no way of affording medical care. For hospitals and physicians, it represented government control of their professions and the potential for

mandated treatment for unbridled numbers of high care, and subsequently high cost, patients (the elderly and the severely poor and/or disabled).

The medical professionals saw government insurance, even limited as it was to those elderly Social Security recipients, as a step toward "socialist medicine" and the loss of professional sovereignty to control who, how and when they could practice medicine. They also fought extremely hard when an early version of the bill only proposed covering hospital costs and not physicians' bills. As such, the "compromise" bill that was eventually passed by Congress and signed by President Johnson allowed reimbursement for doctors' fees for those Medicare and Medicaid patients.

Historian Rosemary Stevens noted Medicare responded to the prevailing political and societal trends and apparent needs of 1960s America. But more significantly, she clarified that "it gave hospitals a license to spend." During the 1970s, Medicare funding to hospitals would subsequently rise two-fold, leading to the resultant rise of government regulation limiting reimbursement. It also confirmed the role of government as purchaser of healthcare services and hospitals as the sellers, placing healthcare into the marketplace. HMOs fill in for the majority of those receiving healthcare services today.

For the Grossmont Hospital physicians around at this time, such as Dr. Ernest Shaw, when looking back some forty-five years later, he recalled the professional concerns and political fights of the AMA to protest and boycott participation in Medicare. Shaw commented that the AMA use of the phrase "socialist medicine" was to express the medical profession's concerns with third-party payments. Shaw also recalled that other than those patients who worked for San Diego's largest employers, Convair or Rohr, "You never knew if you would get paid or not." Shaw and many other doctors concurred that in the end, doctors ended up reducing the number of pro bono cases they served, as many of these patients were now covered.

Grossmont Hospital administrators, like those of all hospitals, braced for the supposed onslaught of both patients and reimbursement paperwork. They had properly prepared themselves by obtaining Joint Commission Accreditation of Hospitals ratings—the first requirement to qualify for reimbursement prior to the January 7, 1966 initial implementation date of Medicare. Then they hired additional staff to prepare for the July 1, 1966 date for acute care coverage and the January 1, 1967 date for participants being covered for long-term care.

In July 1966, Leverett Bristol reported in the *Daily Californian* newsletter that no swarms of patients had rushed the hospital. When asked if he thought

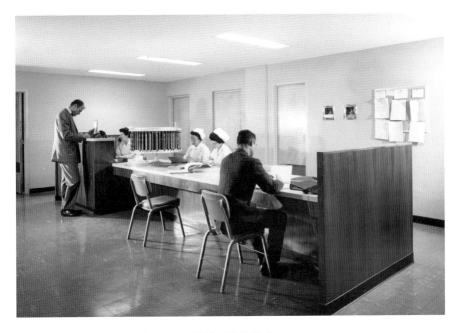

Grossmont Hospital admitting room, 1960. *GH Collection*.

that Medicare would affect the already impacted hospital, he responded, "I see no surge in admissions." A few Medicare patients had scheduled to come in that first week, but Bristol assumed that Grossmont would get "more older folks" as a result. He also noted in an article in the *Capsule* employee newsletter that the bigger change was in the increased workload of documentation, bookkeeping and billing to meet the requirements for reimbursement. As such, the billing for all hospital services—regardless of hospital-based or private physicians—was standardized. Bristol added in conclusion, "These changing times with Medicare are only the first step toward further changes the program will require. It will take the utmost in cooperation by the hospital staff, medical staff and the community."

PREPARING FOR THE 1970S

As Grossmont Hospital entered the 1970s, many of the same concerns of the previous decade were still valid. Medicare had not proved to be immediately disastrous to either hospitals or physicians. However, the hospital was

still facing the challenges of turning away patients due to consistently overcrowded conditions. The inability to get the district voters to support the 1967 bond measure left the much-needed tower unfunded.

In March 1970, Bristol and the board placed a joint-powers authority measure to the district voters to fund the now $10 million expansion project. The partnership with San Diego County established a separate entity to issue the revenue bonds to finance the expansion. The hospital district would then lease the addition from the agency with rental payments over the thirty-year period redeeming the bonds.

The financing plan alleviated some of the voters' concerns. On this third attempt in March 1970, the district's voters approved the measure that would increase the hospital from 216 to 380 beds and add much-needed facilities for X-ray, surgery, laboratory, emergency and other facilities. Alpine businessman Auren Pierce, chairman of the citizens expansion committee that led the campaign, was quoted after the election in the *San Diego Union* that "this program we consider essential to the continued prosperous growth of the east county area."

The hospital reengaged architect Richard Wheeler to complete the drawings. In December 1971, Wheeler's design team, including project leads Virgil White and M.R. Smyth, unveiled the model for the 150,000-square-

Grossmont District Board of Directors, 1970. *GH Collection.*

Grossmont Hospital administrative staff, 1971. *GH Collection.*

foot tower addition. The new building would contain sixteen surgical suites, a twenty-two-bed recovery room, a medical and intensive care unit and a post-care unit. White noted the important contributions from Leverett Bristol and chief of staff and surgeon Robert Hindman's openness to several innovative design elements. The Wheeler team received an American Hospital Association outstanding achievement award for the design, which would match the existing façade of the hospital.

As plans moved forward for bidding in early 1972, the board of directors began to hear rumblings on the feasibility of completing the new addition. In April, the board received word that the state's Tri-County Comprehensive Health Planning Association had not authorized the district's expansion plans due to a technicality. In May, concerned that the project was in jeopardy for Bristol's staff missing the association's filing deadline in March, the board held a closed session. After the two-hour session, the board fired Bristol and two months later appointed his thirty-two-year-old assistant administrator, Ronald Dahlgren, to the permanent hospital administrator position.

6

RISING BUILDINGS, RISING CHALLENGES

New Leadership for New Challenges

Ron Dahlgren had only been at Grossmont Hospital for a little over a year when he was named permanent administrator. The Southern California native had graduated from UCLA with a master's degree in hospital administration. His graduate degree represented the growing field of public health (the UCLA program started in 1961). He had served in a variety of administrative positions at various hospital, health and social service organizations through the Los Angeles area, including as regional manager with the American Red Cross.

Dahlgren's education and broad experience in hospital administration in his relatively short career would be essential in helping the hospital through what became one of the most challenging periods for American hospitals. The general goodwill of American hospitals in the 1950s had changed. The consistently rising costs of hospital care in the 1960s and the initial rampant hospital spending that accompanied the Medicare and Medicaid programs eroded the public's confidence in the healthcare industry's altruistic reputation. Hospital critics attacked what they perceived as uncontrolled spending that was not addressing the public's best interests.

Grossmont Hospital's new administrator and board of directors became targets for similar concerns. Each year, the board seemed to address the constant need to increase tax assessments and grow reimbursement revenues to cover operational and capital costs. Grossmont employees required and demanded salary and benefit increases. The board approved employee

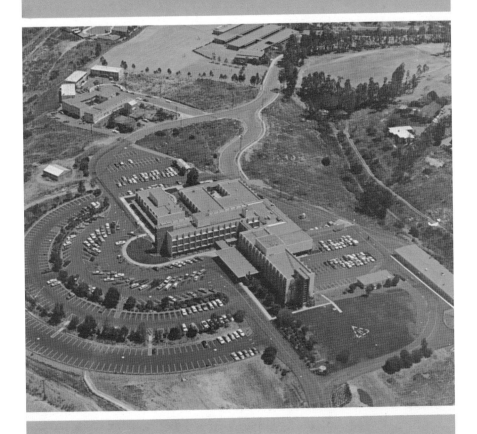

TO SERVE YOU

GROSSMONT DISTRICT HOSPITAL

LA MESA, CALIFORNIA

Grossmont Hospital brochure, 1970. *GH Collection.*

salary and benefit increases in December 1973. In May 1974, pay raises awarded the nursing staff did not stop a four-month-long picketing effort by twelve local labor unions in support of Grossmont's administrative workers that year. Part of the settlement with the unions in July 1974 required the board of directors to recognize all employee bargaining units and agree to collective bargaining. Discussions with the various employee groups resulted in their joining the United Hospital Employees Association in 1976.

Another growing cost concern directly affected the medical staff—the exponential cost of malpractice insurance. As public sentiment changed, many began to perceive healthcare as a right and not a privilege. It also raised expectations of physicians. This triggered a rise in malpractice suits claiming substandard or incompetent care. Subsequently, physicians faced an astronomical increase in malpractice insurance costs in the early 1970s. In early 1975, it was reported that doctors' malpractice insurance premiums had risen 500 percent in just four years. In May 1975, Grossmont physicians joined in a statewide "walk-out" to protest the unregulated increases that threatened many doctors' practices. In 1976, Dr. William Soldmann announced his retirement, claiming insurance cost increases. The challenge for the private practice doctor was illustrated in long-standing staffer Dr.

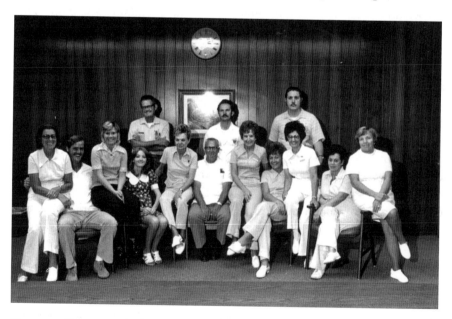

Grossmont Hospital administrative staff, 1975. *GH Collection.*

Sidney Tolchin commenting in a May 1976 interview with the *East County California* that the only way to afford to continue his practice was to risk "going bare"—without insurance.

All of these challenges that addressed the growing costs of care, staffing and physician insurance had, as Ron Dahlgren noted in a December 1978 *San Diego Union* interview, quickly and dramatically "changed the patterns of health care." After the hospital lost significant money in the first quarter of fiscal year 1978–79, it would join with other hospitals struggling to stay solvent in looking to reduce costs and continue care through shorter hospital stays, expanding outpatient care and increasing preventive treatment programs.

Raising the Tower and More

Dahlgren's first task as administrator in the summer of 1972 was to get approval to move forward on the funded six-story tower expansion. Dahlgren had quickly reapplied to the Tri-County Comprehensive Health Planning Association (CHPA) to obtain approval for the hospital's expansion. The quasi-government agency was state-chartered to assist counties with the coordination of regional hospital facilities. The hospital presented its plan at an August 11 public hearing held for the CHPA, after which the CHPA approved the expansion but with possible limits. Dahlgren then led the appeal to the State Comprehensive Health Planning Council in October 1972, finally garnering approval for the full addition for Grossmont Hospital.

With approval finally obtained, Wheeler and Associates was reengaged to complete the plans and specifications. In September 1973, Wheeler completed the plans. In January 1974, the board authorized the sale of $16 million in revenue bonds to finance the new tower and the next phase of work, a $4.5 million physical rehabilitation center. In April 1974, the district held a groundbreaking ceremony for the new $14 million six-story wing with construction starting that fall. In the meantime, planning for the new rehabilitation center moved forward. In 1975, the firm of Kaplan, McLaughlin and Associates was hired to design the new rehab center.

In the midst of this continued growth and expansion, Grossmont Hospital held its twentieth anniversary celebration. For the first time, with all the construction underway, the hospital held the event offsite at the Vacation Village Convention Center. The pre-event publicity promised something

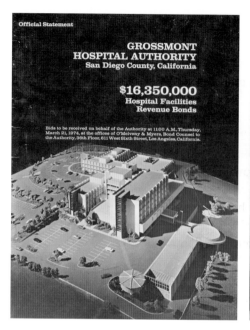

Left: Grossmont District bond statement, 1974. *GH Collection*.

Right: Dr. William Soldmann (*left*) and Forace Boyd at the dedication of Boyd Wing, 1977. *GH Collection*.

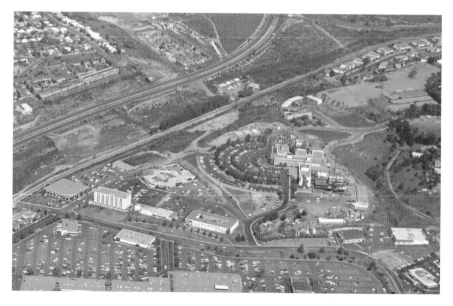

Aerial of Grossmont Hospital complex, including new medical buildings and convalescent facility, 1975. *Grossmont Center Collection, La Mesa Historical Society Archives*.

special, which turned out to be the naming of the new six story tower for long-serving board member Forace Boyd and the naming of the rehabilitation center for first chief of staff and board member Dr. William Soldmann.

From 1975 through 1978, the Grossmont campus was a scene of constant construction. Yet even though the hospital was once again filled to record capacity during this time, construction on both complexes moved forward ahead of schedule. On February 27, 1977, the Boyd Wing was dedicated, and a year later, the hospital admitted the first patients to the Soldmann Rehabilitation Center. Other improvements in the late 1970s included a new $1.5 million expanded hospital lobby, business offices, a library and a doctors' lounge that realigned the hospital entrance.

In addition, Grossmont Hospital officials also worked with the City of La Mesa and the California Department of Transportation to improve access to the hospital. Improvements to the new Grossmont Center Drive and its interchange with the now rechristened Interstate 8 were completed along with a direct rear entrance along the newly extended Murray Drive.

SUPPORTING HOSPITAL ADVANCEMENT

The women's auxiliary continued to be the prime funding and volunteer support organization for the hospital and district. The annual Harvest Ball event continued to raise funds for medical scholarships for East County teenagers and support many new programs. Other fundraising events included regular home and garden tours, an Arabian horse show, theater nights and parking lot bazaar rummage sales. The auxiliary would prove key to helping fund and man various programs, such as the Care-A-Van patient transportation, Meals-On-Wheels senior nutrition program and its historic "candy striper" hospital volunteer program—which in 1975 was opened to males for the first time.

As hospital costs increased, the auxiliary's efforts continued to be invaluable. Auxiliary fundraising in this period helped the hospital acquire hemo-dialysis machines and chest percussive vibrators to help provide new and necessary equipment for the medical staff.

The need to support the medical staff with the latest in medical technology continued to be a focus for not just the generous volunteers of the auxiliary but the whole hospital. In 1973, Ron Dahlgren commented publicly on the importance of keeping up with technology for intensive

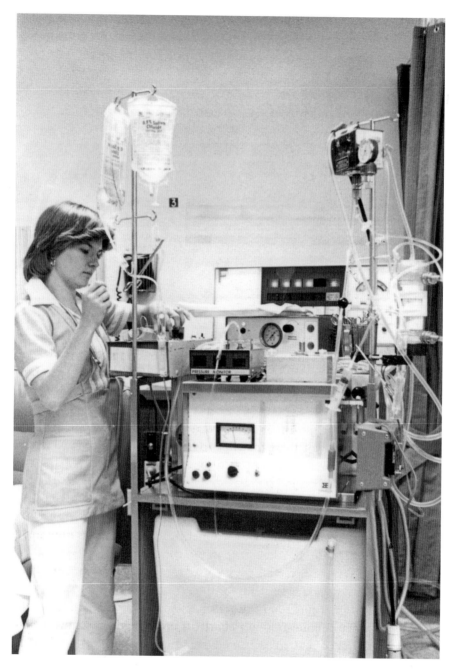

Nurse with hemodialysis machine, 1980. *GH Collection.*

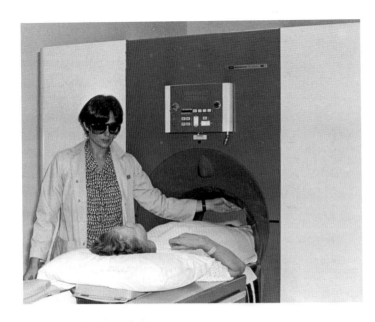

Grossmont
Hospital CAT
scanner, 1976.
GH Collection.

care and diagnostic tools for the medical staff. The next year, amid the continuing challenges of budgetary trials, the board and administration came through with $325,000 to purchase a cutting-edge "brain-scanning device," better known today as a computerized axial tomography, or CAT scanner.

As former radiologist Dr. William Pogue recalled in 2011, Dr. Sidney Tolchin had seen one of these machines during a visit to Europe. Upon his return, the radiology staff approached the administration and board, and to their surprise, the hospital purchased the expensive high-tech machine in 1974. For several years, Grossmont had the only CAT scan unit south of Los Angeles. Such efforts raised Grossmont's reputation as a modern hospital facility. In 1975, it added a full body scanner to address requests from many hospital specialties. Of course, being on the cutting edge put the facility at odds with Medicare bureaucrats who refused to reimburse for some of these new diagnostic tests and treatments for their patients.

In addition to keeping up with technological advances in medicine were the hospital administration's efforts to implement preventive health programs and outpatient treatments. Done for both healthcare and cost-saving reasons, these efforts expanded the hospital district's impact beyond the hospital campus. Dahlgren's public health administrative background was seen in 1973 when he hired Douglas Smith to man the new social services department. Regular public educational courses and programs on

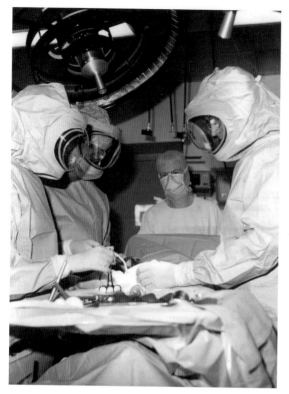

Left: Sterile surgery unit, 1980. *GH Collection*.

Below: Grossmont Hospital booth at community health fair, 1976. *GH Collection*.

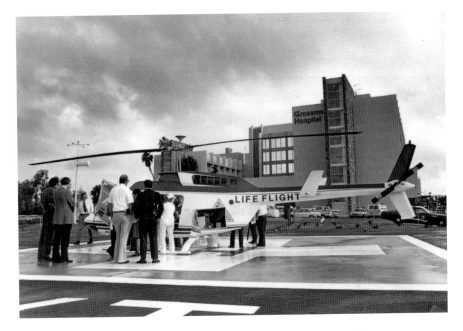

Grossmont Hospital heli-pad with Life Flight helicopter, 1980. *GH Collection.*

personal and public health topics such as women's health, smoking risks, marriage and family life issues, stress reduction, dealing with death and good dietary habits were but a few of these programs.

Other important ancillary efforts in the 1970s included the initial attempts at creating professional ambulance and paramedic services for East County. These efforts required coordination with numerous local public safety agencies, including police, fire and sheriffs' offices and municipalities. Although some jurisdiction turf wars would be part of such discussions, by decade's end, most of East County had paramedic services to help stabilize patients prior to their arrival for acute care services. In the meantime, Grossmont also ensured that many of its nursing staff received paramedic training to increase its staff competencies.

In addition, the hospital instituted its initial outpatient services. In 1977, the outpatient surgery and procedures department opened near the radiology department in the new Forace Boyd Wing. Here the hospital provided what it described as "fast service for the not so sick" to help reduce pressure on the emergency room.

MARKING TIME

Although these were trying times for all, the hospital district did pause to celebrate the great amount of community service it and its employees were accomplishing. At the twentieth anniversary event, Dr. John Hardebeck, former chief of staff and later a district director, served as master of ceremonies, and the presenters reflected with a nostalgic look back at what had been accomplished. The Grossmont Hospital "family" had grown with the community. The board of directors in 1975 oversaw a medical staff of 933, some 955 auxiliary members and 745 other employees. Major programs and services included the district blood bank, Care-A-Van, a chaplaincy program, community health lecture series, parental training programs, Meals-On-Wheels, a minor consent program, pediatric orientation, hospital emergency liaisons, speakers' bureau and translator services for non–English speaking patients.

Five years later, at the hospital's twenty-fifth anniversary, the dinner-dance celebration event capped a week of celebrations and open houses. Grossmont proudly boasted of its having the first CAT scan machine, the largest junior auxiliary volunteer organization in the county and its new

Hospital and Community Information Center, 1976. *GH Collection.*

Grossmont Hospital District

Silver Anniversary

**Vacation Village
August 15, 1980**

Community leaders selected the site in 1952.

25 years of dedication to good health

Grossmont Hospital's twenty-fifth anniversary celebration program, 1980. *GH Collection.*

hospital-operated hemo-dialysis satellite facility in El Cajon, its new on-site mental and physical rehabilitation center and a rooftop garden long-term care unit. Other new programs of note included new cardiac rehab and acute stroke programs along with its short-term surgery and procedures department and paramedic services.

RISING CHALLENGES

Grossmont Hospital faced the 1980s with the same trepidations that most American hospitals did. The blessings and curses of Medicare would soon expedite the coming changes. In 1983, the federal government

fundamentally changed its reimbursement from costs incurred to payment for specific diagnostic categories with set prices. The added regulatory and bureaucratic system would force hospitals to recognize that reimbursement was not guaranteed. Those organizations with the foresight to see what was coming recognized the value of large health maintenance organizations (HMOs) with their large pools of insured members providing steady income if services could be managed efficiently. Interestingly, the board of directors had heard a presentation on HMOs back in 1974 that predicted that by the year 2000 more than half of medical patients would likely be members of these insurance groups instead of patients of private doctors.

For the Grossmont Hospital District Board of Directors, the 1980s would bring these realities into focus. The 1970s had seen rapidly rising costs in dealing with growing staff, financing an expanded physical plant and keeping up with medicine's high tech and pharmaceutical advancements. District budgets required annual increases in fees to attempt to balance costs that would rise as much as 34 percent in a single year. Additional challenges included increased labor and employee concerns and wrongful death and malpractice lawsuits. These new challenges made the elected district board positions less prestigious and more difficult. Starting in the late 1970s, a noticeable change was in the election of a large number of board members who were physicians, registered nurses or had professional experience in the healthcare field—not just local civic or business leaders. In 1973, anthropologist Irene Fancher became the first female director. Fancher would serve until 1980.

The new challenges also became harder to predict. In the early 1980s, the difficulties finding enough qualified nurses were in contrast to predictions of a glut of physicians by 1990. In 1982, the district proposed a new $58 million expansion, but this time, the County Health Systems Agency claimed that Grossmont did not need another 134 beds or a new 700-car parking garage. Citing the growing trend of HMOs and managed care plans, the agency only assumed the hospital's need growing by 21 beds by 1990.

Ron Dahlgren and the district would eventually be able to persuade the Health Systems Agency to allow the plans for a new seven-level tower and other improvements. The 168,400-square-foot tower would raise the hospital's bed count to 550 from 420. Other projects included the purchase and remodeling of the 1958 Briar Patch Elementary School on Wakarusa Drive into a cardiac rehabilitation facility and wellness center, a print shop, a mailroom, an education and training facility, business offices and a home for the soon-to-be created Grossmont Hospital Foundation.

Grossmont Hospital District Board of Directors, *left to right*: James Polak, Kenneth Brown, Irene Fancher, Dr. William Soldmann and Adrian Jameson, 1976. *GH Collection.*

However, such large and expensive expansion plans seemed to contradict other issues. In May 1985, the *San Diego Union-Tribune* covered the expansion projects announcements that coincided with Dahlgren reporting a decline in occupancy that might require the shuttering of the fifth floor of the Boyd Wing and possible staff layoffs. Director George Hurst noted that hospital occupancy decline was due to changes in Medicare and insurance requirements. Hospital nurses openly questioned why layoffs would be considered with some $58 million planned in capital improvements.

This announcement was only five months after Grossmont Hospital's controversial withdrawal from the county's trauma system. Administrator Dahlgren and the staff argued against the costs of operating a twenty-four-hour, seven-days-a-week physician-manned trauma center when the demand was averaging only thirty-five cases a month, with but a handful of required surgeries. A few days later, in January 1985, it was reported that the county had suspended Grossmont's trauma center due to two high-profile cases in which patients to the trauma center had died for lack of an on-duty physician.

Such controversial issues and the questioning of Administrator Dahlgren's leadership continued through the rest of 1985. In November,

after Assistant Administrator Pamela Atkinson resigned, the board of directors voted to terminate Dahlgren's contract after thirteen years. Board president Curtis Kelly was quoted in the *San Diego Union* on the changing conditions and internal strife, "I think the board feels we are into a new era of contract medicine where we need a close, harmonious relationship between the medical staff and the chief executive officer."

The board appointed Associate Administrator Edward Maguire as interim administrator. The search for a new administrator took eighteen months. After three candidates turned down the challenging position, the board hired Michael Erne in August 1986. Erne had most recently served as administrator of the Ventura County Medical Center. Board president Curtis Kelly described Erne as "a top-flight administrator with a proven track record."

Erne moved right into the district's challenges of reimbursement and how to get Grossmont to compete in order to reduce the loss of its market share to the growing hospitals attached to medical systems. Former administrator Ronald Dahlgren, who had taken a job at Alhambra Community Hospital, was asked about what problems Erne would be facing with the large public

Aerial photo of Grossmont Hospital and Shopping Center. New Interstate 8/State Route 125 interchange is under construction (*upper right*), 1989. *La Mesa Historical Society Archives.*

hospital. Dahlgren prophesized, "He will have to work with the board and medical staff to educate them on their need to adapt to the changing health-care industry, by recognizing that he'll have to adapt to groups who want other options in terms of insurance programs."

Little did Dahlgren or the board know how well Michael Erne understood the path Grossmont Hospital and the district would take in order to meet these challenges.

GROWING THROUGH UNPRECEDENTED CHALLENGES

Michael Erne arrived at a time of Grossmont Hospital's first serious episode of fiscal instability and employee anxiety, yet he continued capital expenditure and growth of plant and programs. His first few years in the late 1980s may have seemed a contradiction in goals and direction. While costs escalated, questions as to the hospital continuing to participate in government reimbursement programs such as Medi-Cal were discussed while at the same time developing a Senior Club Plan to sign up district residents for Medicare—while conversely funding and constructing new cutting-edge facilities. Although cost increases were exponential and budget cuts a considered threat, the community's healthcare needs for hospital services still grew.

All parties involved recognized these continuing community needs. In early 1989, Grossmont Hospital still pushed plans to attract physicians and patients in the new, highly competitive healthcare industry when it announced an $81 million expansion, renovation and equipment upgrade program. The five-year plan included new cancer, maternity and emergency room facilities along with a 115,000-square-foot seven-story office building with suites to attract eighty physicians. Erne was quoted in the *San Diego Union* asserting that the project could be accomplished without increasing the district's indebtedness beyond the 1987 sale of $35 million in bonds. For example, the hospital's recent improvements, such as the installation of a $700,000 hyperbaric chamber, had been funded through hospital revenues during these financially challenging times.

Major improvements during this period included the October 1989 opening of the Women's Health Center, a project championed by long-serving obstetrician Dr. Basil Maloney. The two-story sixty-thousand-square-foot building housed twenty-four beds for maternity patients and twelve

beds for premature infants—allowing mothers to deliver, recover and receive post-delivery care in the same room. With the number of births rising again at the hospital (4,213 in 1988), the plan also called for a $1.5 million renovation of the existing maternity and pediatrics facilities.

Other elements of the plan included a $2 million renovation of the emergency room facilities and a $4.9 million cancer center for outpatient treatment. The Cancer Center funding was augmented by the most recently created hospital partner—the nonprofit Grossmont Hospital Foundation. The concept of creating a nonprofit partner to address larger capital needs of the hospital dated back to 1976. The Grossmont Hospital Board established the foundation in 1985 and, under first executive director Bob Randall, worked to build the fundraising base of the new organization to complement the long-standing auxiliary's more operational focused support.

DAVID LONG, MD, AND HIS WIFE DONNA REVIEW PROGRESS OF THE NEW DAVID AND DONNA LONG CENTER FOR CANCER TREATMENT AND CARDIOVASCULAR DIAGNOSIS NAMED IN THEIR HONOR.

David and Donna Long at construction of Long Center for Cancer Treatment, 1992. *Grossmont Hospital Foundation.*

In 1992, the Grossmont Hospital Foundation funneled a generous $2 million donation from El Cajon resident Dr. David Long, inventor of the Norplant birth control device, and his wife, Donna, for the Long Cancer Center. In 1993, the hospital opened the Long Center as well as a new outpatient cardiovascular diagnostic center in El Cajon and the Grossmont Plaza Surgery Center building. Other important program improvements at the time included the hospital's establishment of San Diego County's first residency training program outside of UCSD County Hospital. Thus, as the hospital reached its fortieth anniversary, it had grown from 100 to 450 beds, serving a district population that had risen from 80,000 to over 400,000—but those changes were not the ones garnering the most attention for Grossmont Hospital.

PARTNERING FOR A SUSTAINABLE FUTURE

ORCHESTRATING A PUBLIC-PRIVATE HEALTHCARE PARTNERSHIP

When the hospital held its fortieth anniversary celebration in 1995, it had weathered another storm of recent growth and development. The previous four years had been those of the greatest change and challenge for the district, its hospital and the new operators. As noted, hospital administrator Michael Erne had come into the job understanding that the hospital and healthcare industry were undergoing transformations. Hospital and healthcare providers were recognizing the need to partner and contract with those entities that could provide steady income and efficient management of their operations. As James Lott, then head of the Hospital Council of San Diego and Imperial Counties, was quoted in the *San Diego Union*, "[T]he marketplace is putting more and more pressure on hospitals to join forces."

In May 1990, Michael Erne and Director Adrian Jameson met with Peter Ellsworth, head of the nonprofit Sharp HealthCare of San Diego, for a dialogue on how to enhance each institution with shared services. These initial talks led to further talks with Erne, Jameson and Director George Hurst and Sharp officials. In September 1990, special meetings were held with both the Grossmont and Sharp boards to discuss possible arrangements for merging services between the publicly owned Grossmont Hospital and private nonprofit Sharp HealthCare. Sharp HealthCare at the time operated Sharp Memorial Hospital in Kearny Mesa as well as

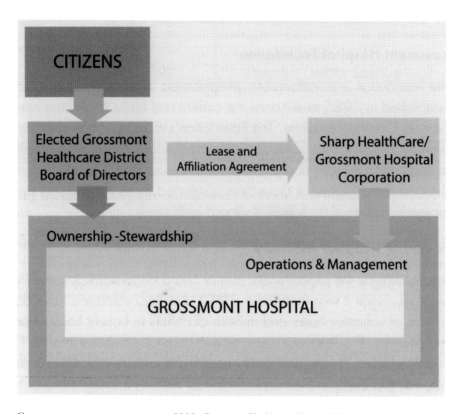

Grossmont governance structure, 2009. *Grossmont Healthcare District Collections.*

hospitals in Point Loma, Coronado, Chula Vista and Temecula in Riverside County, nursing homes and the Sharp Rees-Steely Medical Group.

The merger plans were released to the public in October 1990. The proposed lease would require the formation of a "holding company" to operate the publicly owned Grossmont Hospital. Initial questions and concerns centered on the ability for a private corporation to operate a public asset. The concept assumed formation of a new board made up of five elected Grossmont and six elected Sharp representatives to oversee the new hospital organization. Erne commented on Grossmont's motivation for partnering in the *Union*: "We are trying to predict what the best strategy is to survive the future to carry out our mission for our communities. We have to recognize that a network of hospitals will be in a better position to survive than a hospital standing by itself."

The merger and operating lease moved forward in the spring of 1991. At the March Grossmont Hospital District Board meeting, the merger plan

took its first hit from a large, organized and passionate opposition. Some three hundred district residents attended that meeting, many to voice their concerns with merging their community hospital with a private, albeit nonprofit corporation. Many called for a public vote on the agreement and voiced concerns with perceived improper disbursement of the public's assets. The local Grossmont and East County physicians provided some of the most vociferous opposition. Dr. Dennis Wilcox, a La Mesa surgeon, and Santee surgeon Dr. David Rutberg filed a lawsuit in March 1991 in an attempt to halt the plan. Wilcox and Rutberg contended the merger would harm the quality of care, create a restraint of trade and result in an unintended gift of public assets.

The board still saw the financial benefit as the driving issue. On April 3, 1991, the Grossmont Hospital District Board voted 4 to 1 to approve the lease agreement in principle, with only former hospital chief of staff, San Diego Medical Society president and district board member Dr. Basil Maloney voting against the lease agreement.

The next day, a group called the Citizens Network to Save Grossmont District Hospital began circulating petitions to recall the four board members who voted for the agreement. Sharp's CEO Peter Ellsworth found the opposition perplexing, stating in the *Union* that Sharp was "bringing to the party a lot more than we're getting." Board member Robert Muscio summarized the underlying motivation being the lack of "clout as an individual hospital that we would have as part of a major health system." In May 1991, after Judge James Milliken rejected the doctors' lawsuit, the Grossmont Board voted 4 to 1 again to approve the lease agreement with Sharp. As such, the new Grossmont Hospital Corporation was created to operate the district-owned hospital under Sharp's management.

Although the process for formation of the new operating lease had been contentious, it proved to be at the forefront of where the healthcare industry was headed in the 1990s. Michael Erne and the board majority had recognized the need to gain the scale and clout that managed care contracts brought to healthcare providers' financial stability. Sharp HealthCare was already one of San Diego's most well respected non-profit healthcare providers. As the then new Grossmont Hospital Corporation CFO Michael Murphy recalled in a 2017 interview, the lease agreement provided the capital to refinance and pay off the district's hospital-related debt in much less time and in more favorable terms than it could have achieved without Sharp's resources. The financial stability did not necessarily end the concerns of dissenting district board members,

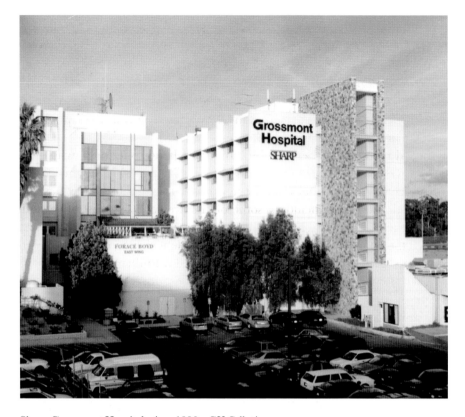

Sharp Grossmont Hospital, circa 1990s. *GH Collection.*

the medical staff and some local citizens over the perceived intentions of Sharp to act in the best interests of the community's hospital. This continued acrimony would fuel later disagreements for the cutting-edge public-private partnership.

NEW PARTNERS, NEW CONCERNS

Grossmont's new public-private partnership with Sharp HealthCare set precedents for California hospital districts and helped stabilize the public hospital's finances, but many concerns over the specifics of the arrangement continued. Although the recalls of the four board directors who voted for the lease in 1991 would fall short, within the next few years, those four would be voted out of office. In 1992, former hospital administrator Robert "Bob"

Yarris and local businessman James Stieringer replaced Adrian Jameson and Robert Muscio. Two years later, Dr. William Herrick, a beloved long-serving Grossmont physician, replaced Curtis Kelly, and in 1996, long-standing director George Hurst was replaced by registered nurse Richard "Dick" Bea. When beloved obstetrician Dr. Basil Maloney, founder of the Women's Health Center and holdout against the lease, passed away in 1995, physician Dr. Armand Wohl was appointed to replace him.

Board members Robert "Bob" Yarris and James Stieringer, who were often on opposite sides of specific issues, recalled in 2017 that this period was often contentious between the new board members, the new hospital corporation officers (including some of the previous administrative staff) and the medical staff. Those members in support of the lease agreement touted the financial benefits, including major debt reduction and improved services, while opponents remained concerned with the sovereignty of the public's hospital, questioning the private corporation's commitment to the taxpayers of the district and their disbursement of district tax revenues.

Those questions of intent rose again in 1995 when the large corporate for-profit healthcare corporation Columbia/HCA offered to join with Sharp. The plan called for Sharp to form a for-profit corporation to operate its hospitals, which the large corporate Columbia/HCA would purchase at a 50 percent ownership share. The invested funds would have been used to retire Sharp's debts and fund its nonprofit San Diego Hospital Association. Both supporters and detractors showed concern over the viability of the deal, specifically as it affected Sharp's lease with the publically owned Grossmont Hospital. Columbia's $195 million proposed investment, however, was something that all those on the boards of both the Grossmont District and Hospital Corporation, including Sharp's Mike Murphy and district directors Bob Yarris and Jim Stieringer, remembered was too significant to not be investigated.

In May 1996, Sharp's board of directors voted to go forward with the partnership. The debate continued to fuel those questioning Sharp and the lease agreement. In July 1996, the Grossmont District Board of Directors signed a letter of intent to lease Grossmont Hospital to Columbia/HCA or conversely withdraw from its lease with Sharp if the agreement proved legally infeasible. In November 1996, the *San Diego Union* reported on California state attorney general Dan Lundgren ruling against the merger between the for-profit Columbia/HCA and nonprofit Sharp HealthCare, calling the agreement "legally flawed." In February 1997, Sharp would drop its merger plans with Columbia/HCA.

Although the state had stopped the merger, it fueled the district board's inquiries into the benefits and legality of the original lease agreement. New board president James Stieringer and the majority of district board members concerned with the lease continued to question the details of the original agreement and its legitimacy. The mid-1990s district board soon had questions as to perceived conflicts of interest existing in 1991 at the lease's origins. These conflicts concerned both the district board members as well as the district and Sharp's legal counsels. All this questioning caused additional concerns as to the partnership agreement. In June 1997, district board member and lease critic Dr. William Herrick summarized the opposing position in the *Union* as to the "one-sided, ill-considered agreement...placing all the assets of the public, tax-supported hospital at the mercy of the private, not-for-profit Sharp." Such concerns as to how the district's tax revenues were being subsumed into Sharp Grossmont Hospital's operations budget were due to the so-called evergreen clause of the original lease. This was the clause that turned all district and hospital revenues to the hospital corporation. This only added to the district board's September 1997 decision to file a lawsuit against Sharp HealthCare in an effort to void the lease agreement.

The lawsuit fueled both support and critique of the district board and Sharp. Grossmont Hospital Corporation board member Dr. William Renart reiterated in a *Union* article that the Sharp-Grossmont "affiliation has proved to be an unqualified success for the hospital and our entire community." In a separate *San Diego Union*–published editorial, Renart questioned the district board's wisdom in using taxpayer funds to sue the operating partner, whose agreement had resulted in $70 million in capital improvements in its first six years, with another $12 million scheduled. The lawsuit would last for several years before a 2001 settlement between Sharp HealthCare and the district. As long-serving district legal counsel Jeffrey Scott explained in 2017, the courts would eventually find inherent conflicts in the original lease agreement, but technicalities in appellate and trial court rulings led to both sides sitting down and working out a settlement, allowing the Grossmont District-Sharp partnership to continue. The final settlement, according to district board President James Stieringer, would "protect the assets of the district," settle the board's concerns and, importantly, end the "evergreen clause." The final 2001 settlement resulted in a $5 million payment to the district, a restructuring of the hospital corporation's board to ensure better transparency and a commitment of district support for completion of a $63 million emergency services facility upgrade. As Michael Murphy, at that

point the CEO of Sharp HealthCare, stated in a *Union* article upon the announced settlement, "[W]e tried to come to an agreement that satisfied their needs and…allowed us to put the resources back into the facility and improve it to do the things we need to do."

Putting Quality and Patients First

Similar to the struggles of the late 1980s, the district and Sharp found a way to keep their mutual goals of providing quality healthcare for the residents of East County at the forefront during the internal political and legal challenges of the 1990s. One of the most notable and fundamental changes was the state's alteration of its California Local Hospital District Law. In 1994, as a result of Senate Bill 1169, the authority and regulations governing California's public hospital districts were updated to match the changed nature of healthcare. The new law rechristened California's "hospital districts" as "healthcare districts." Subsequently, in 1997 the Grossmont Hospital District changed its name to the Grossmont Healthcare District. This change would herald the enhancement of its local grant, preventive and public health programs.

In the late 1990s, the hospital did not rest on the laurels of Long Cancer Center or its Senior Resource and award-winning Women's Health Centers. The post-settlement period reinforced the Grossmont Healthcare District and Sharp Grossmont Hospital's joint commitment to serving the public with the best care possible and the latest in medical technology. In 1998, Sharp Grossmont was the first hospital in the county to have a computerized tomography (CT) scanner with three-dimensional radiation treatment capabilities. In 2000, the hospital opened its first hospice house and was a pioneer in digital imaging technology. In 2004, Sharp opened its new Grossmont Emergency and Critical Care Center facility. The following year, the Long Cancer Center became the first to implement the state-of-the-art TomoTherapy Hi-Art system treatment, an advanced form of radiation treatment device with a built-in CT scanner. In August 2005, the hospital celebrated its "50 Years of Healing" anniversary, now with 481 beds, continuing its role as the largest hospital in East County and one of the busiest in the county. Grossmont's community healthcare role became even more significant due to San Diego's Scripps Healthcare's closing its East County hospital in 2000.

Left: Grand opening program, Grossmont Healthcare Center and Herrick Library, 2002. *Grossmont Healthcare District Collections.*

Below: Grossmont Hospital's fiftieth anniversary flyer, 2005. *Grossmont Healthcare District Collections.*

Another clear effort to enhance the growing public educational aspect of the district was the opening of the Dr. William Herrick Community Health Care Library in May 2002. Herrick, a pioneering Grossmont physician and district board member, was a former director of the hospital's continuing medical education department who had passed away in 1998. The library provides free health resources to all district residents and visitors. The $2 million facility, a concept originated by district president James Stieringer, also included a sixty-five-seat auditorium subsequently named for him and used for district board and public meetings. The complex also includes healthcare district staff offices and a Gallery of Honor with exhibits on East County history.

Planning for the Future

The partnership's commitment to expand and support Grossmont Hospital's mission to provide public access to high-quality and innovative medical facilities and staff would likely have been difficult for either Sharp or the district to finance alone. One example of how the district-Sharp public-private relationship benefitted was the passage of Proposition G in 2006. In the first decade and a half of the relationship, Sharp had been the major investor in the hospital's innovation and expansion. Then in 2006, as long-standing board member Gloria Chadwick and Sharp CEO Michael Murphy recalled in 2017, the hospital was in need of an estimated $1 billion in improvements that Sharp was not in position to fund expediently.

Therefore, the district board offered up the public district's ability to use general obligation bonds to finance improvements as had been done in the past. In early 2006, the new district CEO, Barry Jantz, and the board worked with hospital CEO Michelle Tarbet and their staffs on the list of projects for which the $247 million Proposition G (G for Grossmont) general obligation bond measure would be used. These joint projects included the completion of the hospital's partially completed emergency and critical care center, upgrades and expansion of rapid-response cardiac care capabilities (later the Heart and Vascular Center), ninety new patient beds, structural upgrades for earthquake building code compliance in two aging wings and ensuring facilities in support of district resident access to emergency and hospital care services.

Proposition G Campaign advertisement, 2006. *Grossmont Healthcare District Collections.*

The district-sponsored Proposition G campaign recalled the early campaigns of the 1950s in brevity, coalition-building and political success. On June 6, 2006, Prop G passing with 77.8 percent of East County voters approving the measure to tax themselves for the public benefit that Grossmont Hospital provided. Not only did the general obligation bond measure see no significant opposition and pass overwhelmingly, but the bond measure also included creation of the Independent Citizens' Bond Oversight Committee (ICBOC). The ICBOC is a nine-member volunteer citizens group that provides oversight of the district's expenditures and ensures that both partners effectively and efficiently manage the public bond funds.

The Proposition G funds enabled Grossmont, as Sharp CEO Michael Murphy recalled, to proceed more expeditiously than without the partnership. In September 2009, Grossmont completed its first phase priority, the revitalized five-story Emergency and Critical Care Center. As Sharp Grossmont COO Maryann Cone noted in the *San Diego Union*, the ninety new rooms—twenty-four intensive care and sixty-six fully monitored—provided the staff and patients with the latest in medical technology and facilities. The second phase included work to complete the new Heart and Vascular Center, complete renovation of the 1974 Main Patient Tower (Boyd Wing) and modernization of the hospital's energy plant.

Over the ensuing years, Prop G funds helped complete additional projects. In 2015, district and hospital staff celebrated the renovation of floors two through five of the seven-story Main Patient Tower. The improvements

included new technical and monitoring equipment, reconfigured patient and staff space and mechanical, electrical, plumbing, accessibility and seismic upgrades. In March 2016, Grossmont completed its new Heart and Vascular (H&V) Center. The H&V Center expanded the hospital's surgery capabilities with new labs and procedural rooms. The new center expanded pharmacy facilities for research studies, including investigational drug therapies. In 2017, construction on the center's new surgery floor began with plans for a 2018 completion. Another important partnership project through Prop G was its completion in December 2016 of the $60 million Central Energy Plant with its new $14 million cogeneration system paid for by Sharp. As district president Michael Emerson noted in a *Union* article reporting on the December 20, 2016 celebration, the hospital was no longer solely reliant on the electrical grid, saving millions in energy costs and reducing the hospital's greenhouse gas production 90 percent.

The continued success of these Prop G projects and other joint programs are due to a combination of key planning efforts and one additional public proposition. In 2012, the Grossmont Healthcare District Board of Directors met to complete a district strategic plan. The resulting district's Strategic & Risk Management Plan was completed the following year. The district

Grossmont Hospital Foundation founding member Virginia Napierskie in front of the Heart and Vascular Center she helped fund, 2016. *Grossmont Hospital Foundation.*

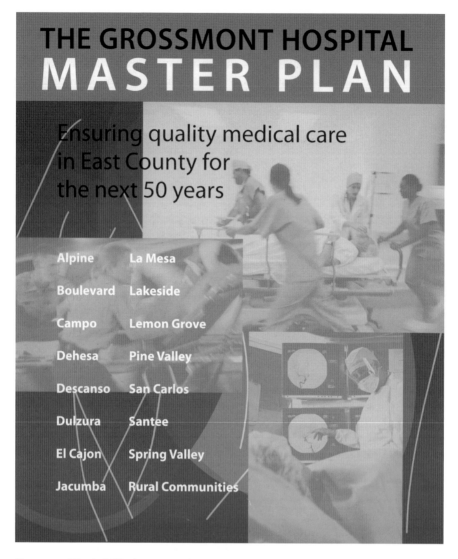

THE GROSSMONT HOSPITAL
MASTER PLAN

Ensuring quality medical care in East County for the next 50 years

Alpine La Mesa

Boulevard Lakeside

Campo Lemon Grove

Dehesa Pine Valley

Descanso San Carlos

Dulzura Santee

El Cajon Spring Valley

Jacumba Rural Communities

Grossmont Hospital District master plan, 2006. *Grossmont Healthcare District Collections.*

reiterated its mission to both monitor the healthcare services provided at Grossmont Hospital and to anticipate and recognize the unmet healthcare needs of the communities it represented. One of the strategic objectives of the 2013 plan was to work collaboratively with Sharp HealthCare and the Grossmont Hospital Corporation to initiate a successful lease renewal. In 2014, district CEO Barry Jantz led the Proposition H (for hospital)

campaign, effectively utilizing legislation created by Assemblyman Jay La Suer that 86 percent of East County voters approved to extend the once controversial, but now stable operating agreement lease through 2051. As Jantz commented in 2017 on the renewed support represented in the Prop G and H victories, "For fairly conservative East County to overwhelmingly support a tax increase and a public-private lease renewal, it speaks to the strength of the District-Sharp partnership in meeting the community's desire for hospital services."

GROSSMONT HOSPITAL TODAY

Grossmont Hospital and Healthcare District have seen a whirlwind history of serving East County's healthcare needs for well over six decades. Today, the hospital represents, as current Sharp HealthCare CEO Michael Murphy noted, "a very integral part in the overall fabric of healthcare in San Diego County." Its unique public-private partnership with Sharp HealthCare provides a fiscal stability that has allowed it to continue to meet its and the healthcare district's missions to provide quality healthcare through availability of cutting-edge facilities that attract and support the continuously dedicated team of physicians, nurses and hospital staff.

SHARP GROSSMONT HOSPITAL

Sharp Grossmont Hospital, the Grossmont Hospital Corporation Board and its administrative and medical staffs continue to be dedicated to serving the East County community with the largest and most comprehensive healthcare services possible at the landmark community institution. It also continues to be a major employer for East County, with 2,700 physicians and 18,000 employees of the Sharp HealthCare system at its disposal. The list of Grossmont Hospital medical departments includes anesthesia, cardiology, emergency medicine, family medicine, internal medicine, OB-GYN, orthopedics, pathology, pediatrics, psychiatry, radiology and surgery. These departments are also buoyed by a highly trained and qualified medical staff overseeing a diverse and active set of medical committees, ensuring the latest in knowledge and training opportunities.

The Sharp Grossmont Hospital Corporation Board has been the operating entity of the hospital since 1991. Scott Evans, PharmD, MHA, is the senior vice president and CEO of Sharp Grossmont. Evans joined Grossmont in 2015 and follows a long and impressive list of qualified administrative chiefs at Grossmont Hospital. The corporation board consists of several Sharp HealthCare board directors, two Grossmont Healthcare District directors and additional appointed members.

Sharp Grossmont Hospital is part of the greater Sharp HealthCare system. Sharp's history is contemporary with Grossmont Hospital. Thomas Sharp, a San Diego broadcast business pioneer, donated $500,000 in 1950 to the San Diego Hospital Association to establish a new hospital in his son Donald N. Sharp's name. Donald served as a World War II air corpsman and was killed in action. Sharp Memorial Hospital opened in 1956, and today, in addition to Grossmont Hospital, the well-respected healthcare system operates acute-care hospitals in Coronado, Kearny Mesa and Chula Vista as well as three specialty hospitals, three affiliated medical groups and a health plan. Michael Murphy, first CFO of the Grossmont Hospital Corporation in 1991, has been president and CEO of Sharp HealthCare since 1996.

GROSSMONT HOSPITAL AUXILIARY

The hospital has built on its community-based service tradition, as is represented by the sixty-five-year-old Grossmont Hospital Volunteer Auxiliary (the current version of Nan Couts's original women's auxiliary). Since the auxiliary's founding in 1952, it has donated over $3 million to benefit the hospital and its patients. The auxiliary operates the Thrift Korral store in La Mesa as well as two hospital gift shops (one in the hospital lobby and one in the Women's Health Center) to help raise funds in support of the hospital operations. In addition, the auxiliary has been a constant and current supporter of hospital volunteer programs and community healthcare education efforts.

GROSSMONT HOSPITAL FOUNDATION

Founded in 1985, the Grossmont Hospital Foundation seeks to enhance the current and future healthcare needs of East County through the support of patient care, health education, clinical research and major capital projects at Sharp Grossmont Hospital. Over the previous thirty-plus years, the Grossmont Hospital Foundation has raised and allocated more than $90 million to support Grossmont Hospital, Sharp HospiceCare and associated projects and programs. Notable capital projects benefitted include the Women's Health Center, Long Cancer Center, Emergency and Critical Care Center, Heart and Vascular Center and daVinci surgical robots. The foundation's overhead is allocated from Sharp Grossmont Hospital so that all donations can be passed directly to the programs and services with no overhead or administrative costs deducted. Major active foundation programs include the Guardian Angel Program, an annual golf tournament, memorial gifts and other fundraising events, such an annual sailing regatta and fall gala. The foundation's formal 501(c)(3) nonprofit status has proved to be an effective tool for attracting large donations from individuals, corporations and institutions.

One of the foundation's notable philanthropic relationships has been made with the longest standing cultural community in the region—the Kumeyaay Nation. The foundation stewarded the Barona and Sycuan bands' generous donations in support of cutting-edge Grossmont Hospital programs such as the robotic surgery program. This type of philanthropic development resulted in other significant pledges, such as Ron and Mary Alice Brady's 2015 donation of $2 million in support of the Central Energy Plant.

A board of governors establishes foundation policies and fundraising priorities that align with Sharp Grossmont, Sharp HospiceCare and their governance organizations. The board is led by El Cajon attorney Lewis Silverberg and includes eighteen civic, business, medical and community leaders in support of the hospital and the foundation's role for East County healthcare. Elizabeth Morgante, a certified fundraising professional, has served as the executive director of the Grossmont Hospital Foundation since 1994 and has been instrumental in the growth and success of the foundation.

GROSSMONT HEALTHCARE DISTRICT

After sixty-five years, the Grossmont Healthcare District continues to strive to provide the best resources and information to address the healthcare needs of East County. (The district also includes San Diego neighborhoods Del Cerro and San Carlos.) The district is governed through a publicly elected five-member board of directors. The directors represent the over 500,000 residents of the 750-square-mile district. The district's mission statement reflects the change from its hospital district origins to its broader healthcare purpose:

> *To maintain and improve the physical and behavioral health of its constituents, the healthcare district will:*
> *—Partner with our hospital operator, Sharp HealthCare, to ensure access to state-of-the-art medical services at Grossmont Hospital for all of the residents of Grossmont Healthcare District and beyond.*
> *—Anticipate and recognize the unmet health care needs of the communities we serve and support suitable services to the greatest extent possible consistent with available resources.*

Grossmont Healthcare District Board of Directors, *left to right*: Randy Lenac, Virginia Hall, Michael Emerson, Gloria Chadwick and Robert "Bob" Ayres, 2017. *Grossmont Healthcare District.*

In meeting its mission, separate from its partnership oversight of Grossmont Hospital, the district operates the Grossmont Health Care Center with the Dr. William Herrick Library and James Stieringer Conference Center at Briarcrest Park. In addition, the district supports many nonprofit, health-related community programs and services throughout the East County region. Nearly one-half of its property tax revenues are distributed through its community grants programs.

The board of directors in 2017 reflects the continuation of the dedicated public servants that have been a part of its storied history: retired banker Robert "Bob" Ayres, registered nurses Gloria Chadwick and Virginia Hall, businessman Randy Lenac and optician and current president Michael Emerson, RDO, FNAO. District CEO Barry Jantz also has a long history with the district and East County public service. His professional background includes stints as financial services manager with Kaiser Permanente and chief of staff to Assemblyman Jay La Suer. Barry also served on the La Mesa City Council from 1990 to 2006.

Conclusion: A Legacy of Service

The story of Grossmont Hospital is one that is reflective of the historical events and trends of American hospitals and their response to the unique evolution of healthcare in this country. It also reflects on the unique community spirit that has been a characteristic of East San Diego County. From its suburban and rural suburban communities such as La Mesa, El Cajon, Lemon Grove, Del Cerro, San Carlos and Mount Helix to the more rural areas farther east into the Mountain Empire, Grossmont Hospital has proven to be an institution that has garnered support unlike few others.

The idea of a community hospital for East County could legitimately be traced to the early 1920s, but it was the post–World War II era, buoyed by the unprecedented federal and state funding for community hospitals, that triggered a rapid chain of events. From formation of the state-sponsored and publicly created Grossmont Hospital District in January 1952 to an even more astoundingly efficient design, construction and open-for-service Grossmont Hospital in August 1955, East County has perhaps never been more in agreement on any other local civic issue.

Grossmont Hospital grew exponentially along with the community over the next twenty-five years, adding buildings and physicians and serving

Grossmont Hospital District coat of arms logo, 1955. *GH Collection.*

thousands of residents in need of health services. Although the hospital continued to grow in the 1980s, it would be affected, as were all healthcare institutions, by the challenges of a rapidly and significantly changing healthcare industry. Although the next fifteen years ushered in a period of political and professional unrest and strife, the bottom line was that the Grossmont Hospital continued to serve its constituents to the best of its ability to meet its mission.

What can be learned from this difficult period was that the unique and groundbreaking public-private partnership, so debated and divisive for many, resulted in a financially stabilized institution that allowed for the continuation of high-quality service all parties desired and fought to accomplish. In the end, the resulting settlement provided a landscape that has allowed for this long-standing, innovative and essential public institution to continue to position itself to fulfill its legacy of service for many more decades to come.

SOURCES

NOTES ON SOURCES

The majority of sources used to compile this work come from the Grossmont Hospital Historical Collection. The collection includes miscellaneous newsletters, photographs, ephemera and other documents relating to the establishment, management and operations of the hospital and hospital district since 1952. It also includes twenty-one annual scrapbooks with newspaper clippings and photographs compiled in 1980 for the twenty-fifth anniversary of the hospital by former administrative assistant Evelyn Foreman. The original collection resides at Grossmont Hospital, but a copy of the materials can be found in the archives of the La Mesa Historical Society, La Mesa, California.

The La Mesa Historical Society Archives includes a historical photograph collection and various collections and holdings, including that of the nearby Grossmont Shopping Center Management Files (1957–2014) along with copies of the local *La Mesa Scout* and *El Cajon Valley News* newspapers, which proved invaluable sources.

The fully digitized version of the *San Diego Union* and *Tribune* newspapers, dating from 1868 through 2017, were accessed through online databases and microfilm available through Love Library, San Diego State University.

Introduction

McCauley, Bernadette. "Hospitals." In *Oxford Encyclopedia of the History of American Science, Medicine and Technology*. New York: Oxford University Press, 2014.

Rosenberg, Charles E. *The Care of Strangers: The Rise of the American Hospital System*. New York: Basic Books, 1987.

Starr, Paul. *Remedy and Reaction: The Peculiar American Struggle Over Health Care Reform*. New Haven, CT: Yale University Press, 2013.

————. *The Social Transformation of American Medicine: The Rise of a Sovereign Profession and the Making of a Vast Industry*. New York: Basic Books, 1984.

Stevens, Rosemary. *In Sickness and Wealth: American Hospitals in the Twentieth Century*. Baltimore, MD: Johns Hopkins Press, 1999.

Chapter 1

Amero, Richard. "The U.S. Naval Hospital and Balboa Park." Unpublished manuscript, San Diego History Center Archives, San Diego, CA, n.d.

Finley, Bill. "A History of Mercy Hospital." Unpublished manuscript, San Diego History Center Archives, San Diego, CA, 1990.

Graves, Clifford L. "An Early San Diego Physician: David Hoffman." *Journal of San Diego History* 10, no. 3 (July 1964).

Kelly, Michael M.D., ed. "Introduction, First Annual Report of the Board of Health of the City of San Diego for the Year 1888." *Journal of San Diego History* 48, no. 4 (2002): 282–90.

————. "Introduction, First Annual Report of the San Diego County Hospital and Poor Farm to the Board of Supervisors, for the Year Ending June 30, 1889." *Journal of San Diego History* 48, no. 4 (2002): 363–69.

Miller, Linda E. "San Diego's Early Years as a Health Resort." *Journal of San Diego History* 28, no. 4 (1982).

San Diego Herald. Various issues (1851–56), San Diego State University, Love Library, San Diego, CA.

San Diego Union. Various issues (1869–1945), San Diego State University, Love Library, San Diego, CA.

Chapter 2

Grossmont Hospital Historical Collection. Including scrapbooks, historical files and photographs. Grossmont Hospital, with copy at La Mesa Historical Society Archives, La Mesa, CA.

La Mesa Historical Society Archival Collections. Including county directories, biographical files and microfilm copies of *La Mesa Scout* (1941–52).

San Diego Union. Various issues (1869–1945), San Diego State University, Love Library, San Diego, CA.

Taylor, Margaret. "California's Health Care Districts." California Healthcare Foundation, April 2006.

Chapter 3

Chadwick, Jean. Interview with Rick Griffin, June 2017. Notes in author's collection, La Mesa, CA.

Grossmont Hospital Historical Collection. Including annual scrapbooks, historical files and photographs. Grossmont Hospital, with copy at La Mesa Historical Society Archives, La Mesa, CA.

Jones, Burton. Oral history interview with Dr. Craig Carter, February 20, 1984. Typescript, SDHS Oral History Program, San Diego History Center Archives, San Diego, CA.

La Mesa Historical Society Archival Collections. Including county directories, biographical files and microfilm copies of *La Mesa Scout* (1941–52).

San Diego Union. Various issues (1952–55), San Diego State University, Love Library, San Diego, CA.

Sharp Grossmont Hospital Oral History Collection. Video oral histories of former Sharp Grossmont Hospital physicians and staff. San Diego County Medical Society Foundation, San Diego, CA. Copies on file at Sharp Grossmont Hospital and La Mesa Historical Society Archives.

Chapter 4

Grossmont Hospital Historical Collection. Including annual scrapbooks, historical files and photographs. Grossmont Hospital, with copy at La Mesa Historical Society Archives, La Mesa, CA.

Hardebeck, Patty. "Reminiscences of Dr. John 'Jack' Hardebeck," e-mail correspondence, June 2017. Author's collection, La Mesa, CA.

La Mesa Historical Society Archival Collections. Including county directories, biographical files and microfilm copies of *La Mesa Scout* (1955–61).

San Diego Union. Various issues (1955–61), San Diego State University, Love Library, San Diego, CA.

Sharp Grossmont Hospital Oral History Collection. Video oral histories of former Sharp Grossmont Hospital physicians and staff. San Diego County Medical Society Foundation, San Diego, CA. Copies on file at Sharp Grossmont Hospital and La Mesa Historical Society Archives.

Chapter 5

Grossmont Hospital Historical Collection. Including annual scrapbooks, historical files and photographs. Grossmont Hospital, with copy at La Mesa Historical Society Archives, La Mesa, CA.

La Mesa Historical Society Archival Collections. Including county directories, biographical files and microfilm copies of *La Mesa Scout* (1961–71).

San Diego Union. Various issues (1961–71), San Diego State University, Love Library, San Diego, CA.

Sharp Grossmont Hospital Oral History Collection. Video oral histories of former Sharp Grossmont Hospital physicians and staff. San Diego County Medical Society Foundation, San Diego, CA. Copies on file at Sharp Grossmont Hospital and La Mesa Historical Society Archives.

Starr, Paul. *The Social Transformation of American Medicine: The Rise of a Sovereign Profession and the Making of a Vast Industry.* New York: Basic Books, 1984.

Stevens, Rosemary. *In Sickness and Wealth: American Hospitals in the Twentieth Century.* Baltimore, MD: Johns Hopkins Press, 1999 edition.

Chapter 6

Grossmont Hospital Historical Collection. Including annual scrapbooks, historical files and photographs. Grossmont Hospital, with copy at La Mesa Historical Society Archives, La Mesa, CA.

La Mesa Historical Society Archival Collections. Including County Directories, biographical files and microfilm copies of *La Mesa Scout* (1971–85).

San Diego Union. Various issues (1971–92), San Diego State University, Love Library, San Diego, CA.

Sharp Grossmont Hospital Oral History Collection. Video oral histories of former Sharp Grossmont Hospital physicians and staff. San Diego County Medical Society Foundation, San Diego, CA. Copies on file at Sharp Grossmont Hospital and La Mesa Historical Society Archives.

Starr, Paul. *Remedy and Reaction: The Peculiar American Struggle Over Health Care Reform*. New Haven, CT: Yale University Press, 2013.

Stevens, Rosemary. *In Sickness and Wealth: American Hospitals in the Twentieth Century*. Baltimore, MD: Johns Hopkins Press, 1999.

Yarris, Robert. Telephone interview with author, June 2017. Author's collection, La Mesa, CA.

Chapter 7

Chadwick, Gloria. Telephone interview with author, June 2017. Author's collection, La Mesa, CA.

Grossmont Hospital Historical Collection. Including annual scrapbooks, historical files and photographs. Grossmont Hospital, with copy at La Mesa Historical Society Archives, La Mesa, CA.

Jantz, Barry. Personal interview with author, June 2017. Author's collection, La Mesa, CA.

La Mesa Historical Society Archival Collections. Including county directories, biographical files and microfilm copies of *La Mesa Scout* (1990–2017).

Morgante, Elizabeth. Personal interview and e-mail correspondence with author, June 2017.

Murphy, Michael. Telephone interview with author, June 2017.

San Diego Union. Various issues (1990–2017), San Diego State University, Love Library, San Diego, CA.

Scott, Jeffrey. Telephone interview with author, June 2017.

Sharp Grossmont Hospital Oral History Collection. Video oral histories of former Sharp Grossmont Hospital physicians and staff. San Diego County Medical Society Foundation, San Diego, CA. Copies on file at Sharp Grossmont Hospital and La Mesa Historical Society Archives.

Stieringer, James. Telephone interview with author, June 2017.

Yarris, Robert. Telephone interview with author, June 2017.

INDEX

ABOUT THE AUTHOR

Author James D. Newland, a La Mesa resident, historian and manager with California State Parks, has partnered with the Grossmont Healthcare District to create this brief history of the landmark publicly owned community hospital. A graduate of San Diego State University, he has authored several other histories on the La Mesa and East County regions.

Visit us at
www.historypress.net
···